MORE
J
TORONTO
SKETCHES

*Dedicated to Yarmila,
my wife of twenty-five years,
and counting.*

MORE TORONTO SKETCHES

"The Way We Were"

Mike Filey

DUNDURN PRESS
Toronto & Oxford

Editor: Nadine Stoikoff
Designer: Andy Tong
Printed and bound in Canada by: Webcom Ltd., Toronto, Canada

The publisher wishes to acknowledge the generous assistance and ongoing support of **The Canada Council, The Book Publishing Industry Development Program** of the **Department of Communications, The Ontario Arts Council, The Ontario Publishing Centre** of the **Ministry of Culture, Tourism and Recreation**, and **The Ontario Heritage Foundation**.
 Care has been taken to trace the ownership of copyright material used in the text (including the illustrations). The author and publisher welcome any information enabling them to rectify any reference or credit in subsequent editions.

J. Kirk Howard, Publisher

Canadian Cataloguing in Publication Data

Filey, Mike, 1941–
 More Toronto sketches

ISBN 1-55002-201-6

l. Toronto (Ont.) – History. I. Title.

FC3097.4.F54 1993 971.3'541 C93-095354-1
F1059.5.T6857F54 1993

Dundurn Press Limited	**Dundurn Distribution**	**Dundurn Press Limited**
2181 Queen Street East	73 Lime Walk	1823 Maryland Avenue
Suite 301	Headington, Oxford	P.O. Box 1000
Toronto, Canada	England	Niagara Falls, N.Y.
M4E 1E5	OX3 7AD	U.S.A. 14302-1000

Front cover photo is from a turn-of-the-century postcard.
 Church Street, looking north, near Queen Street. Toronto, Ontario.
Back cover photo of Mike Filey courtesy of *Toronto Sun*.

Table of Contents

INTRODUCTION

Back in the fall of 1992 when the good people at Dundurn Press and I decided to assemble a selection of my *Toronto Sunday Sun* "The Way We Were" columns in a book, little did we realize just how well *Toronto Sketches* would be received by readers. Soon after the book arrived in local bookstores, the first printing of 3,000 was sold out and a second printing was quickly on the way.

Eventually it was decided to publish a second collection of "The Way We Were" columns under the title *More Toronto Sketches*, and this time not only would we use material from early 1993 editions of the *Sunday Sun*, but some of my earliest columns that ran in the mid-1970s would be featured as well. In those early days, the amount of space allotted for my column was minimal and depended in many cases on what else was to appear on the page. As a result, the text is fairly succinct and often only one photo accompanied the column. As the popularity of the column increased, so too did the space it was assigned and "The Way We Were" now runs a full half-page.

In *More Toronto Sketches* the reader will note that the date the column first appeared is included. In some cases additional material has been added if relevant changes have occurred since that original appearance.

ACKNOWLEDGMENTS

There are many people who, over the 18 or so years that I have been contributing material to the *Sun*, have assisted me with photos and/or stories. Many of those are *Sun* readers and to all of them, a sincere thanks.

Always helpful are the people in the City of Toronto Archives nestled away in the basement of 'new' City Hall. I'd particularly like to express my gratitude to Glenda, Steve, and of course, to Victor, the boss.

To the ladies in the *Sun* library, Joyce, Kathy, Glenna, Catherine, and Julie, thanks for all the help, and the cookies.

To Vena, Marilyn, and Kaye, people who work in the Life section, the area of the *Sun* where my column appears each Sunday, a special thanks. My gratitude as well to Eric and Don, the boys out in the back room, who always make my stuff look good.

And to Kirk Howard, Ian Low and their staff at Dundurn Press, Nadine Stoikoff, Andy Tong, Judith Turnbull, Jeanne MacDonald, Eileen Craig, Karen Heese, Christine Lumley, and Gordon Heyting, a hearty thanks.

'AMERICA'S SWEETHEART' IS A TORONTONIAN

February 23, 1975

Gladys Marie Smith is said to have been born in the centre two-story building at 211 University Avenue in 1893. Eight years later the family moved to the States and little Mary started her rise to stardom. A plaque has been erected on the lawn of the Hospital for Sick Children which is the site of Mary Pickford's birthplace.

Mary Pickford died on May 29, 1979, and was buried in Forest Lawn Cemetery, Glendale, California.

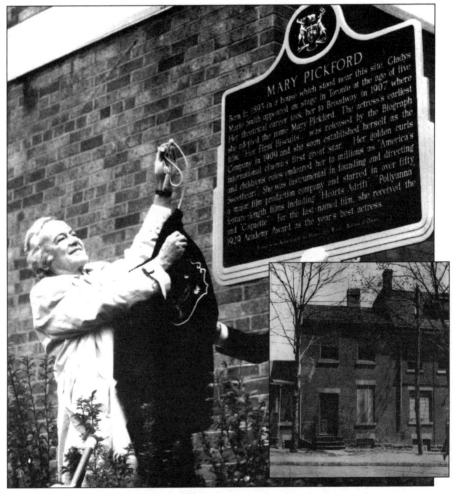

Mary's husband, Buddy Rogers, unveils commemorative plaque at University Avenue and Elm Street, site of Mary's birthplace (insert).

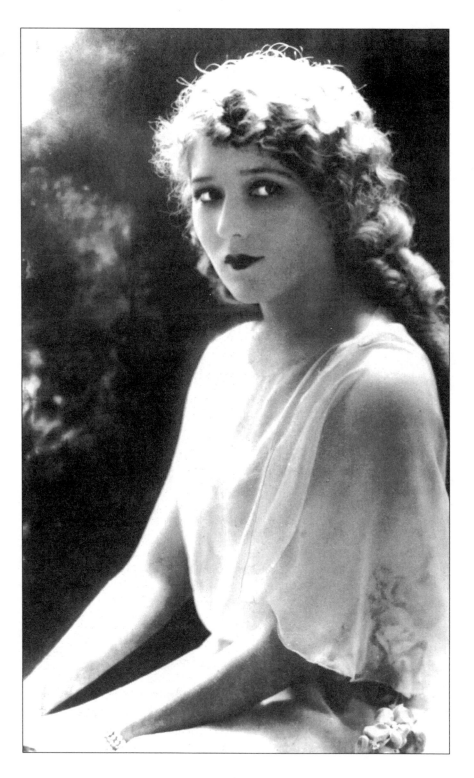

THE HOSPITAL SHOULD BE PRESERVED

December 11, 1975

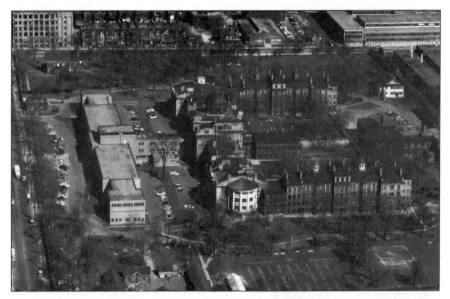

Aerial view of hospital complex, 1974. Howard building is visible in the middle of the view.

There has been much in the media recently regarding the province's decision to demolish what is today known as the Howard Building at the Queen Street Mental Health Centre. To be specific the structure under consideration is the old building with the dome at 999 Queen Street.

In discussing the pros and cons of demolition, the most common reasons for destroying the building are the supposed 'bad things' that took place there. It always had a frightening reputation and children were often warned that if they didn't behave they would wind up in '999.' Visions of inmates staring from the windows "waiting to escape" also led to the public's fear of the building.

Discounting these 'feelings,' one could argue that the structure, when it opened in 1848, was the best example of its kind anywhere on the continent. It also typified a new age of enlightenment in the treatment of mental illness.

But let's look at the building from another viewpoint. It is one of the few remaining examples of the work of one of Toronto's most important citizens, John George Howard.

Born just outside London, England, on July 27, 1803, John Howard arrived in York, now Toronto, on September 14, 1832, after an ocean voyage that included a mutiny, his near drowning, and near destruction of the vessel in the St. Lawrence.

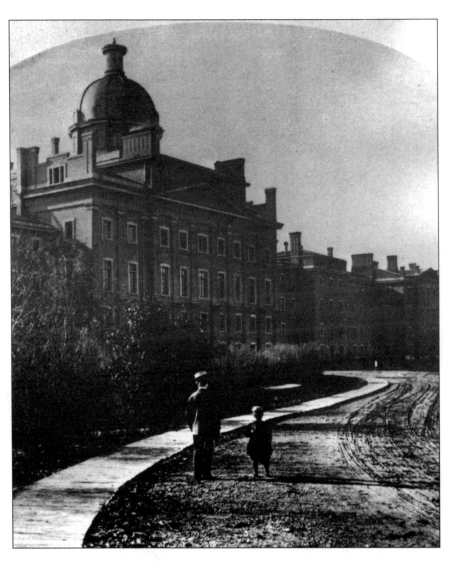

Howard's first employment in his newly adopted town was as the drawing master at Upper Canada College. Soon, his talents in architecture brought requests from prominent citizens to design many houses and commercial buildings, not only in little York, but throughout Upper and Lower Canada as well.

In 1834, Howard was appointed the first city surveyor and in this capacity he built many public buildings, surveyed the harbour, oversaw the construction of various public works, and laid the first sidewalk in the city.

Some of the structures for which Howard is responsible include: Colbourne Lodge (1836), certain engineering improvements to Osgoode Hall and the layout of the grounds, St. John's Anglican Church, York Mills (1843), the Provincial Asylum (1846), and the House of Industry on Elm Street (1848).

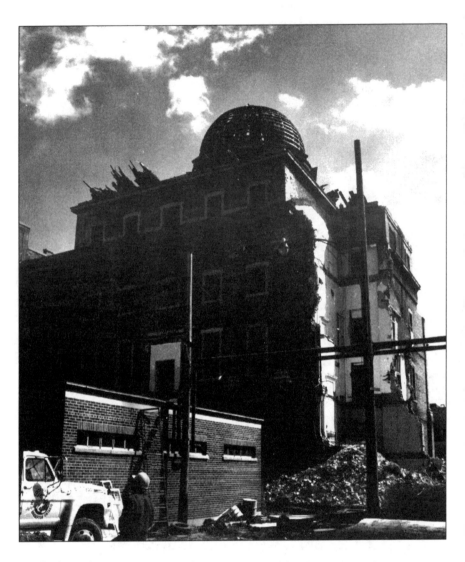

Perhaps the most important thing Howard did for the citizens of Toronto was to deed his property to the enjoyment forever of all Torontonians and visitors to his city. This property is today known as High Park, 165 acres of lush woods and quiet waters in the heart of Metro.

Today, the province wants to demolish Howard's structure that forms the central building of the Queen Street Mental Hospital. John Ross Robertson's *Landmarks of Toronto* takes us back to the mid-1840s and the day that the structure was commenced, with all the pomp and ceremony worthy of a structure that at that time was second to none in the enlightened treatment of those unfortunates termed "lunatic":

The morning of August 22, 1846, was dull and threatening and it was feared that the day's proceedings would be seriously interfered with, but it cleared up, and about 2:00 o'clock the various bodies who were to take part in the day's proceedings began to assemble at the government house on King Street.

First came the band of the 81st regiment from the old fort, then the fire companies, followed by members of the St. George's, St. Andrew's, and St. Patrick's societies, each bearing its own banner. Then came the Home District and City Councils, the Chief Justice and judges and a large number of prominent citizens.

On arrival at the grounds, the company proceeded to the northwest corner of the building. The architect Mr. J. G. Howard placed in [the] cavity in the corner stone an almanac, a city directory, various city newspapers, and an assortment of coins.

The stone was well and truly laid by Chief Justice John Beverly Robinson who then addressed the assembly on the fine merits of the Provincial Asylum. The band played Rule Britannia, and the crowd dispersed. The building formally opened in June of 1848.

Now we come to the crux of the discussion. Should this landmark be destroyed because it's old? It can be restored at a cost not much greater than the renovation of the 1846 structure as proposed by the Ministry of Government Services. By the way, this renovation includes demolition of Howard's structure to make way for a 250-car parking lot.

Should it be demolished because it's a throw-back to the old way of doing things? Nonsense! In its day it was the best we had. Would you tear down the 62-year-old Toronto General Hospital because people had died in there before certain cures (developed in that same building) became available?

The Ontario Heritage Foundation, created by an act of our provincial government, states that we should retain those structures which have been important to our society.

John Howard was an important Torontonian. His work and civic mindedness were important to the development of Toronto as a major city. His building could continue to be an important component of the Queen Street Mental Health treatment complex. It should not be demolished for the sake of a 250-car parking lot!

This column was written in defence of a proposal to retain and restore architect John George Howard's building that formed part of the Queen Street Mental Health Centre. In spite of compelling arguments that suggested the structure be retained and restored, the provincial government of the day proceeded with a request for demolition tenders. Soon after this article appeared, the historic building was no more.

CHILLING MEMORIES

February 22, 1976

A hundred years or so ago, the city's most fashionable skating rink was the Victoria, located at the southwest corner of Sherbourne and Gerrard streets, a site now occupied by an enlarged Allan Gardens. The rink was built in 1862 by Messrs. Arnold and Wardell and measured 75' by 200'.

An article appearing in an 1863 edition of the *Canadian Illustrated News* reported on a grand prize skating match at this rink. It was considered the great event of the season, and many "fair women and brave men" looked forward to it with delight. It was the first of the kind that had taken place in the city. The frost the night before had hardened the ice sufficiently to permit practising in the forenoon before the actual contest. At noon it was thought advisable to haul down the flag, as the frozen surface was being deeply cut by magic irons. At about 1:30, hundreds of the élite began to arrive. Indulgent parents came to admire the agility of their daughters on skates. It was estimated that more than 1,000 people were present.

The article continued:

> About half past three, the judges advanced to the centre of the rink, and requested that the ladies who wished to compete for the first prize would enter the rink. There was a commotion among the spectators, and thirteen young ladies instantly rushed forward. It reminded one of the pictures of a fairy scene, as the skaters flitted hither and thither, surrounded by a large circle of enchanted admirers, while Maud Quadrille Band played many lively airs.
>
> The ice, however, was in bad condition for the large ladies, and, in consequence, a few fell by their skates breaking through, while the younger and lighter ones glided along without accident. Beautiful skating was now witnessed. The scene presented an animated appearance and joy was unconfined, while youth and beauty chased each other with flying feet.

Mayor John George Bowes was present as well, and commented on how much better skating in the crisp winter air was for the body and soul than was the heated air of the dance ballroom.

The accompanying sketch from the John Ross Robertson Collection shows the Victoria rink in the early 1870s.

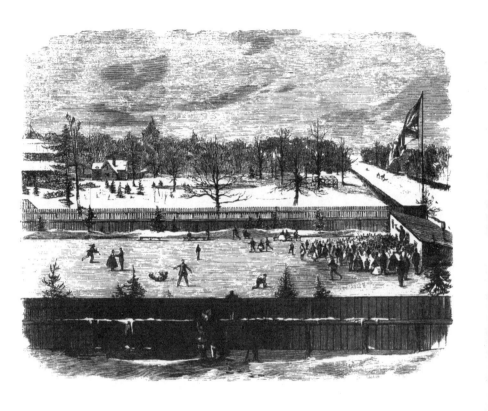

PARKDALE LANDMARK IN DANGER

March 21, 1976

In the 1870s Parkdale was a little village on the western boundary of Toronto, complete with its own main street (Queen), bustling shops, and several industries.

Parkdale grew steadily and in 1885 the decision was made to change its municipal status from village to town. Four years later Parkdale became the 11th parcel of land to be annexed by the mushrooming city next door.

On March 23, 1889, Parkdale's 557 acres became St. Alban's Ward in the City of Toronto.

One of Parkdale's features was the railway station near the corner of Queen and Dufferin streets. The first station was erected in 1856 by the Grand Trunk Railway and served passengers on the Toronto–Kitchener line.

As Parkdale grew, plans were made to construct a larger station and in 1885, the same year Parkdale became a town, a new Grand Trunk station was opened. In the ensuing years Parkdale's station was enlarged by the addition of baggage and freight rooms to the north and south ends.

Today the 1885 station still stands – but its days are numbered.

By this August, Canadian National Railways, successor to the Grand Trunk, has decreed that the little station must go to permit rearrangement of trackage in the area.

In an effort to preserve this landmark of Parkdale, a community that celebrates its centennial in 1978, a small committee has been formed to investigate moving the station to some other location.

It's not going to be an easy job.

The old station sags under the weight of nearly a century of service. Its gingerbread trim peeps wearily from under countless coats of paint.

But if enough people become interested, the station could be preserved to play an important part in Parkdale's centennial celebrations.

As it turned out, the Parkdale Save Our Station Committee raised enough money to have the old structure moved to the small park on the south side of King Street near the foot of Roncesvalles Avenue. Unfortunately, less than nine months after the February 6, 1977 move, the little station was completely destroyed by fire.

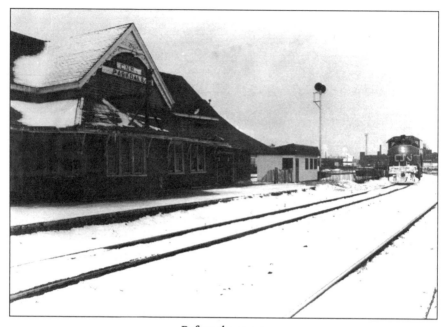

Before the move.

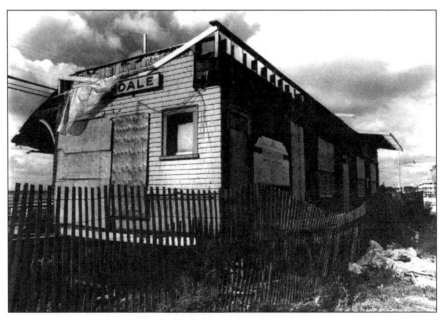

Before the fire.

LONG LIVE THE KING

May 16, 1976

One of this city's fine old landmarks has a new lease on life. Opened on May 11, 1903, the King Edward Hotel on King Street was for many years Toronto's largest hotel. Its contemporaries were the old Queen's on Front, the Arlington on King West, the soon-to-be-no-more Walker House at York and Front, and the Prince George at King and York.

In the early days of the King Eddy, there were separate floors, registration desks, and entrances for the women customers. Waiters were forbidden entrance into the rotunda unless they were buying cigars for a customer.

Edward, the Prince of Wales and grandson of King Edward VII, after whom the hotel was named, stayed here during his visit in 1919. The local flappers did their best to break into the suite to meet the young prince. And who could forget the fuss when Valentino, Pavlova, or Jack Dempsey called the hotel 'home' for a few days.

Built by George Gooderham, of the Gooderham and Worts Distillery fame, the King Edward Hotel first consisted of an eight-storey structure containing 400 rooms, as in this early postcard view (opposite page). In 1922, an addition to the east of 17 floors and 450 rooms was constructed. The Palm Room had the reputation of being the best place in town for a drink and it was one of the first establishments in the city where you could see the fair sex drinking.

From the hotel's earliest years, the management put special emphasis on luxury. Throughout the hotel, ornate carvings, metal work, pottery, and paintings were on display. Of special interest was a terra cotta statue of Venus which was said to have been unearthed in Greece and dated from 300 BC. Most of these treasures disappeared during the Depression years.

Recently, there have been rumours that the hotel is about to be demolished. In fact, a new fashion mart, which will take over three full floors of the hotel, will ensure a prosperous future for the King Eddy. As a way of showing off, the hotel management has instituted a Sunday brunch complete with a free one-hour tour of downtown Toronto on a 53-year-old streetcar.

Since this column appeared in the spring of 1976, the hotel underwent several ownership changes plus a major renovation programme that resulted in the King Edward once again becoming one of the most elegant hotels in the city.

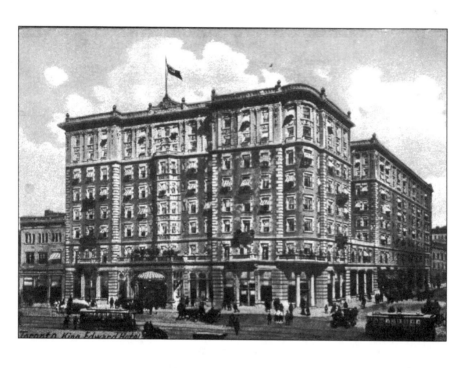

Toronto. King Edward Hotel.

THIS PLACE ISN'T FOR THE BIRDS

June 6, 1976

Hidden in an out-of-the-way corner of downtown Toronto is this marvellous structure, now the home of the Canary Restaurant. A review of early city history indicates that the main portion of this structure was erected in 1848 as a schoolhouse. The city directory for 1861 lists it as Palace Street School. In 1890, the building was remodeled and opened as the Irvine House with Robert Irvine as the proprietor. Two years later, the business was purchased by a Mr. Darcy who changed the name to the Cherry Street Hotel. It had 40 neatly furnished rooms as well as ladies' and gentlemen's parlours, sitting rooms, and a dining room serving the best food obtainable at the St. Lawrence Market. The hotel was quite close to the Grand Trunk Railway's Don station on Queen Street and it had the reputation of being the best dollar-a-day hotel in the whole city.

In later years, the building was used by the General Steel Ware Company. In fact, their signs can be seen through the faded paint on the side of the structure. Today, judging from the multitude of trucks parked in front, the building is as popular as it was in Darcy's time; this time, though, it's for the food, not the bed.

This column resulted in several readers calling the restaurant to request dinner reservations. Be assured no advance reservations are necessary.

CANADIANS ON THE 'UNSINKABLE' *TITANIC*

April 17, 1977

Sixty-five years ago today, the world still wasn't sure what had happened. Were *Titanic's* passengers safe? How many had drowned? All they really knew for sure was that the 'unsinkable' queen of the Atlantic had sunk. The *Evening Telegram* of April 16, 1912, under a heading "Toronto People in Peril," listed the names of eight Torontonians who were thought to have been on board the 46,000-ton, 882½-foot-long vessel. As it turned out, four of those on the list did die in the tragedy; two were saved; and two more had made the transatlantic trip on some other vessel. In all, 25 Canadians were aboard *Titanic*. Twelve died and thirteen survived the ordeal. Charles Hays of Montreal, the president of the Grand Trunk Railroad, was one of the victims.

The most prominent local citizen on the vessel was Major Arthur Peuchen, the president of Standard Chemical, Iron and Lumber Company. His experience as a yachtsman on Toronto Bay enabled him to man one of the lifeboats that carried some of the 651 passengers and crew members away from the foundering vessel. In addition, 54 were later plucked from the icy water. Fifteen hundred and two perished.

The accompanying illustration shows an ad that never appeared in print. It had been prepared to describe *Titanic's* return voyage from New York to Southampton which was to take place just six days after the liner sank.

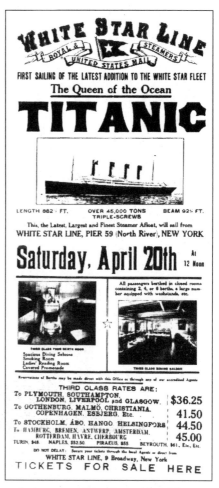

The 'Queen of the Ocean' would never make her 20 April sailing from New York, so proudly advertised by the White Star Line, but *Titanic* continued to dominate public attention for months.

The fascination with *Titanic* is almost as strong today as it was 65 years ago. Two new books, *Raise the Titanic* by Clive Cussler and *The Liners* by Terry Coleman, have recently been published, and Walter Lord's classic *A Night to Remember* has just been released in a fascinating new illustrated edition.

BOB AND TIM AND YONGE AND QUEEN

February 6, 1977

Well Tim, I'll sure be sorry to see you move away. We've been neighbours for a mighty long time. I can remember when I arrived here in Toronto after operating that little store of mine in Newmarket. Let's see, the year was 1872, and you'd been in business for three years. Funny thing, your place was where our store is now, on the southwest corner of Yonge and Queen, and I opened up a place just north of Queen near today's Reitman store.

In a few years, 1883 I think, you needed a bigger place and moved into Charlie Page's row of stores in the same block as my store. I moved my store into larger premises too, just to the south of your old place.

I remember that day in 1884 when you brought out your first catalogue, and in the following year you got a telephone – number 370, as I recall. And you sure shook up the other shop owners in town when you started closing your place on Saturday afternoons in July and August back in 1886. That was the same year you started expanding your shop. Oh, and that first elevator of yours. Remember, you had to put mannequins in the little car to entice your customers to ride in it.

And next week, you'll be moving up north, up to Dundas. All the best, my good friend; the old corner won't be the same without you.

Your friend,
Robert Simpson

On February 9, 1977, Eaton's will vacate their Queen Street and College Street stores. The following day they will reopen in the new Eaton Centre at Yonge and Dundas streets.

Not only did Eaton's move into their new store at the north end of the sparkling new Eaton Centre (followed soon thereafter by the demolition of the company's old store at Yonge and Queen streets), the Robert Simpson store, too, has been altered. In June 1991, the Hudson's Bay Company removed the name Simpson and renamed the store The Bay. Robert is still remembered in Toronto, however, thanks to the adjacent Simpson Tower which opened in 1971.

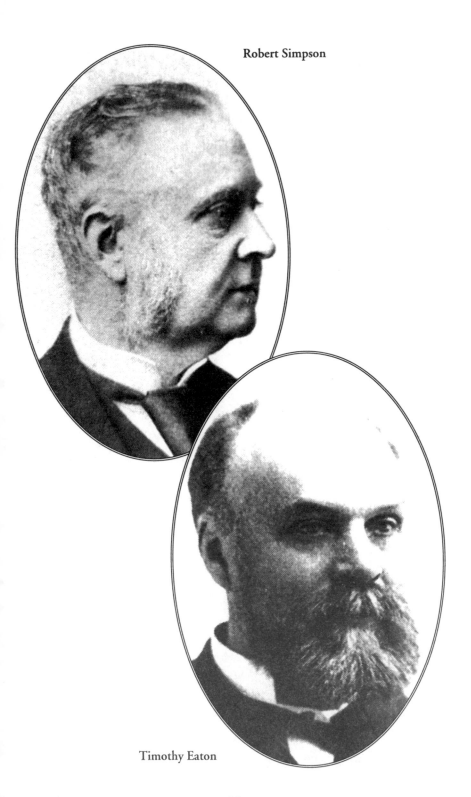

Robert Simpson

Timothy Eaton

HONOURING THE GOOD DOCTOR

July 3, 1977

Tucked away in a corner of Kew Beach Park just south of Queen Street East is a memorial dedicated to the memory of one of that area's most beloved citizens – Dr. William Young. For many years at the turn of the century, Dr. Young looked after the needs of countless hundreds of Beaches residents. The patient's ability to pay was never a concern of the good doctor.

Following his death, a fund was established to erect a suitable memorial to his memory. A drinking fountain was finally erected, done in the Italian renaissance style. It is 14 feet high and mounted on an Indiana limestone platform. There are four carved archways and in the centre of the arches is a figure of a young child. Two of the arches carry bronze likenesses of Dr. Young. Many years ago the figure of the child was stolen.

The upkeep of the fountain is the responsibility of the Toronto Historical Board which has agreed to spend several thousand dollars to obtain a replica of the figure and to do other restorative work. The Historical Board has established a fund for those who might remember the doctor or wish to assist with the restoration of the memorial. Donations should be sent to the Toronto Historical Board, Stanley Barracks, Toronto, Canada M6K 3C3.

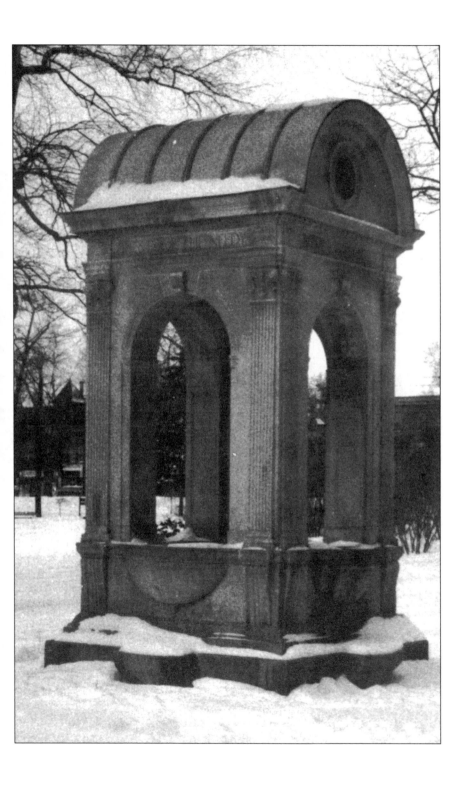

NEW BUILDING THE CAT'S MEOW

July 24, 1977

Some of the finest institutions in our metropolitan area are the various humane societies that protect and assist our animal friends. The Toronto Humane Society was formed in 1887 by a newspaper reporter named J.J. Kelso and the society's first office was at 103 Bay Street. Twenty-six years later, the society moved to 197 McCaul Street (shown below) where they remained until 1928 when the Wellesley Street West facilities opened. Now, nearly a half-century later, larger quarters are necessary and plans are under way to construct new facilities at the northeast corner of Queen and River streets.

Why not take out a membership in the Toronto Humane Society, 11 Wellesley Street West.

The Toronto Humane Society's new headquarters building, which opened in 1982, is located at 11 River Street.

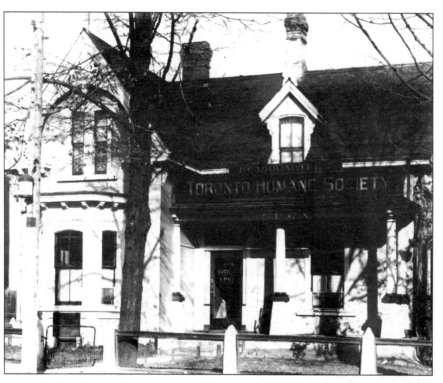

103 Bay Street.

FAIR BEGINNING

August 14, 1977

The 99th Canadian National Exhibition opens this Wednesday, and the 1977 version of the 'world's largest annual exhibition' is a far cry from the fair staged in 1852.

In that year the Provincial Agricultural Association, the forerunner of our present CNE, held its seventh annual fair near the present-day College-University Avenue intersection on an 18-acre open field.

The first such fair was held six years earlier at the southwest corner of King and Simcoe. Subsequently, the event was held in Hamilton, Cobourg, Kingston, Niagara, and Brantford.

These earlier fairs were primarily agricultural in nature, with large numbers of cattle, horses, swine, sheep, and poultry competing for 1,470 pounds in prize money.

Of special interest at the 1852 fair was a prize-winning fire engine, a farmer's flax dressing and scutching machine, and examples of cabinetry by Messrs. Jacques and Hay of this city.

Surprisingly, none of the historical paintings by Paul Kane depicting contemporary life and manners were awarded any prize because these works were not considered by the judges "to come under the designation Historical."

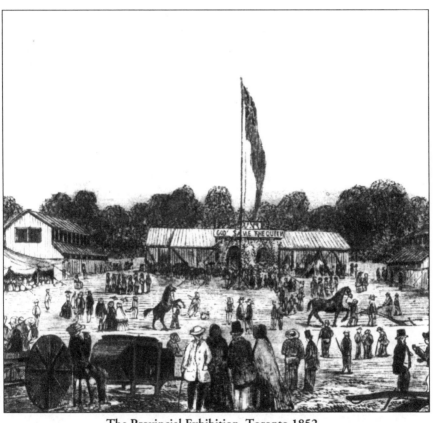

The Provincial Exhibition, Toronto 1852.

THESE GUYS WERE ALL WET

August 21, 1977

Fifty years ago this year, the Wrigley Marathon Swim was staged for the first time at the CNE, following the successful marathon swim in California earlier in the year, which was won by Torontonian George Young. The contest was held here on August 31 with prize money of $50,000 at stake.

On the opposite page you can see part of the huge crowd that gathered to witness the event, while offshore is the official boat, the *Dalhousie City*. The 21-mile event was won in 11 hours and 42 minutes by 'Speedy' Ernst Vierkoetter. The marathon swims were a feature for many years and while they started on a triangular course of three seven-mile arms, they were eventually cut back to 15 miles. Many famous personalities acted as official starters. Below is cowboy star Tom Mix at the 1937 Exhibition. You can see the Wrigley trophy on display in the Queen Elizabeth Building at this year's Ex.

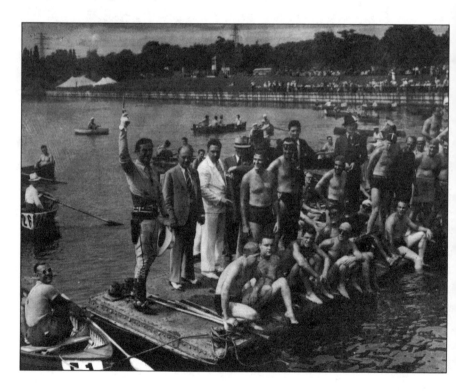

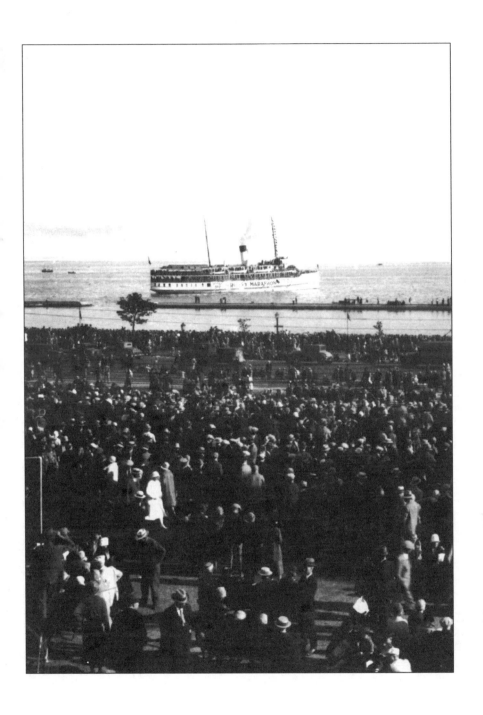

SITES AND SOUNDS AT THE EX

September 4, 1977

Whether you were in the market for a new vacuum cleaner or a 'new-fangled' talking machine, they were on display at the Ex. Above, a group of Ex-goers is about to visit the Columbia record exhibit at the 1908 fair. Columbia's trademark was "Note the Notes." This year marks the 100th anniversary of recorded sound and the Automotive building. All 100,000 square feet of it is devoted to the record industry. Some of the equipment used in the 1908 display can be heard along with the latest quad sounds. In the 1913 photo, a Domestic Vacuum Cleaner salesman demonstrates the sturdiness of his product which was billed as "the best on earth."

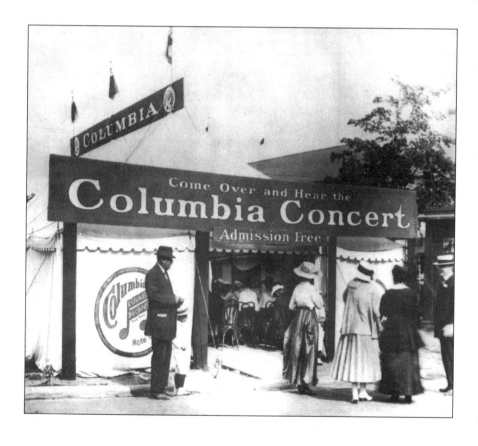

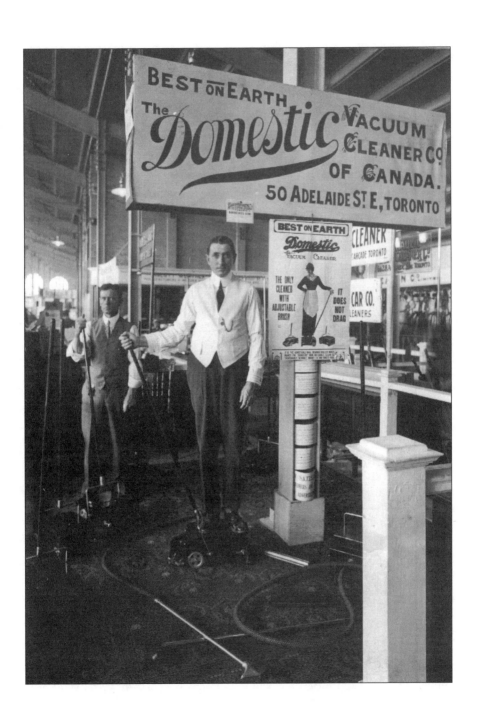

A TORONTO TRADITION

August 15, 1993

Many hate it. Many more love it. But one thing all will agree on is that Toronto wouldn't be the same without it. What is 'it'? Why the Canadian National Exhibition, of course, presently revving up and ready to greet the millions who will visit the

Princes' Gates under construction in the late spring of 1927. Note hand-powered cranes.

114th edition of this great Toronto tradition. The 1993 Ex opens on Wednesday and runs until Labour Day, Monday, September 6.

In its earliest years the Ex, then called the Toronto Industrial Exhibition, was quite literally a dawn-to-dusk attraction. Without the ability to illuminate the grounds and buildings once the sun had set, Exhibition staff simply shooed the visitors out and closed the gates at 6:00 pm.

This remained a standard practice for the fair's first three years. Then, in 1882, it was decided that a new invention, the electric light, would be installed throughout the grounds in an effort to see whether the mandatory 6:00 pm curfew could be broken.

This idea of trying something new was not an unusual move for the fair's officials to make. After all, the whole reason for creating an annual exposition in the first place (and its predecessor fairs were held as early as 1846) was to introduce the public to the latest innovations in the fields of agriculture and industry.

In 1879, over on Yonge Street, the owner of McConkey's Restaurant had installed a pair of carbon arc lights, and soon people were visiting the restaurant to witness the new invention and sample some of the eatery's famous ice cream. The crowds were enormous and soon the restaurant was filled to capacity every evening with customers eager to see and be seen.

Unlike the incandescent light bulbs that Thomas Edison, a frequent visitor to Toronto, was busily perfecting, the carbon arc lamp gave off a brilliant, almost blinding glare, eminently suitable for lighting large areas, but completely useless for illuminating residences.

Other attempts to use electric lamps to combat the darkness were tried with varying degrees of success. Prior to the opening of the 1882 edition of the Toronto Industrial Exhibition, officials decided to conduct their own experiments with

electric lighting. Their decision was based on the success of a similar experiment conducted at the old Adelaide Street skating rink the previous winter. Owners of the rink had installed a number of carbon arc lights over the ice surface, thereby allowing its visitors to skim over the ice even though the surrounding streets were barely navigable under the faint glow of the few gas lamps installed in the neighbourhood. The experiment met with complete success and soon patronage at the rink climbed to new heights.

Similar view, 1993

Exhibition officials, taking their cue from the skating rink project, contracted with two American companies to bathe the Exhibition Grounds with electric light during the run of the 1882 fair. The Fuller Electric Lighting Company put up about three miles of wire and 60 arc lights with half of their total installation within the massive Crystal Palace, the fair's main exhibit hall. The Ball Electric Light Company installed some two miles of wire and 40 lamps.

The power for creating the electricity that was to be fed through the wires to the arc lamps came from dynamos owned by each competing company that were installed in the Machinery Hall at the northwest end of the grounds. Each dynamo in turn was belt-driven by a huge steam engine installed and owned by the Exhibition Association.

The lights first glowed on September 3, 1882, a few days before the fair opened. On September 13, for the very first time, an evening banquet was held on the grounds under the glow of the new lights.

Another two years were to pass before local politicians decided that Toronto, too, would have its streets illuminated by electric arc lamps. The last of the once omnipresent gas lamps finally disappeared in 1911.

• • •

One of the city's true landmarks (and which has one of the most misspelled, mispronounced titles) is the Princes' Gates (not Princess) erected at the east entrance to the CNE Grounds in 1927. The landmark received its plural, possessive title in honour of Edward, Prince of Wales (1894–1972), and his brother George, the Duke of Kent (1902–1942), who dedicated the structure, in the rain, on August 30, 1927. Though the subject of numerous photos today, the rare photo (opposite page) from the City's Archives department is one of the few showing the massive $150,000 structure under construction.

A BUILDING WITH MANY STORIES

September 11, 1977

Established on January 1, 1883, by a vote of 5,437 to 2,932, the Toronto Public Library opened in the old Mechanic's Institute building at the northeast corner of Church and Adelaide streets. The Institute itself had been formed in 1830 to provide educational facilities for the working class of the town. The building, shown below, was designed free of charge by architects Cumberland and Storm, and built for $48,380 on a plot of land which cost $6,529. The library moved to its later $275,000 structure at College and St. George streets in 1909. Later this month, the new Metro Library on Yonge Street, north of Bloor, will open. It will house 1,220,750 books on 28 miles of shelves. The building site cost $7 million, while the five-storey structure was erected for $23 million. Happy reading!

The new Metropolitan Toronto Reference Library (opposite page) was officially opened on November 2, 1977.

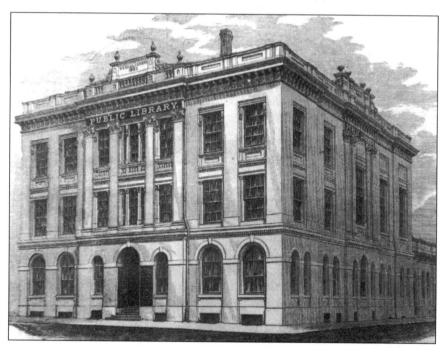

Mechanic's Institute.

WINTER WAS FUN IN OLD 'TO'

December 25, 1977

The big day is tomorrow and I thought it would be fun to look at what Torontonians were doing to celebrate the Christmas season in the early years of this century. Down on the bay ice-boats skimmed over the frozen surface, while over on the Don River hundreds of skaters skimmed over the stretch between the Winchester and Queen Street bridges.

Snow-shoeing was a popular winter sport, especially on the snow-clad hills of Rosedale. Over at High Park adventurous couples were whizzing down the snowy slopes on massive bob-sleds, each emblazoned with the builder's name on the front runner. Back downtown, how 'bout taking in a friendly hockey game between the "Belles of Bloor Street" and the "Ladies from Lansdowne." Following morning church services, skaters at the Moss Park rink on Sherbourne at Queen Street donned long dresses, fur muffs, and bowler hats, and celebrated the festive season to the strains of the "Skater's Waltz" or the "Blue Danube" as performed by the Queen's Own Rifle band.

But the expression is the same now, as it was then – **Merry Christmas**.

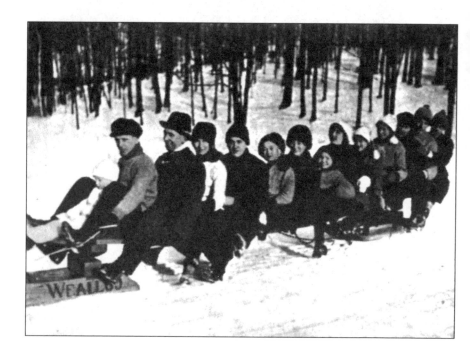

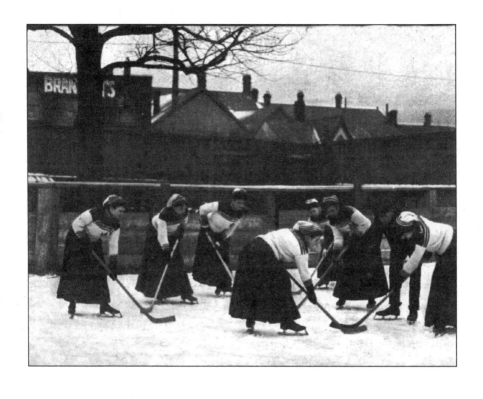

THEATRE FULL OF MEMORIES

January 1, 1978

Going back 22 years to December 31, 1956, one of this city's most popular movie houses closed its doors for the last time. Located on Bay Street, just north of Queen, Shea's Hippodrome opened in 1914 when Bay was still known as Terauley.

The owners were the Shea brothers, Mike and Jerry, and the 'Hip' was their third theatre in Toronto. The first, known simply as Shea's, opened on Yonge Street in 1899 and the second, the Victoria, at Victoria and Richmond streets.

Over the years, many of the great, and near great, stood in front of the footlights of these Shea's theatres and entertained Toronto audiences with song and slapstick.

The Marx Brothers, Red Skelton, 'Bojangles' Robinson, Fannie Brice, Jack Benny ... the list goes on and on.

In 1929, the Hippodrome reluctantly introduced talking pictures and, ironically, the most profitable attraction at the 'Hip' was a talking picture, *Buck Privates*, starring Bud Abbot and Lou Costello.

It played for 14 weeks to packed houses. Kim Novak, Jack Webb, and Elvis Presley made personal appearances to plug their films before the doors closed in 1956.

Out of the ruins of the demolished Hippodrome rose the stunning City Hall and square of architect Viiljo Revel.

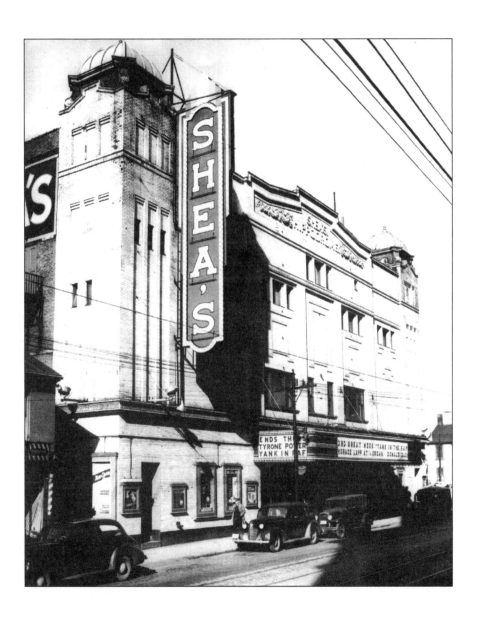

GOING UNDERGROUND

January 22, 1978

Next Saturday, Toronto's newest stretch of subway will increase the total mileage to 32.

It all started 29 years ago – September 8, 1949 – when work on Toronto's first subway began. The Yonge Street subway was also Canada's first subway, and upon completion was 4.6 miles in length. It cost a mere $66 million to build.

The accompanying photo shows a view looking north on Yonge Street from Louisa, taken in April 1949. The next addition to our underground system was the controversial 2.4-mile University subway built at a cost of $40 million and opened on February 28, 1963.

Three years later – February 26, 1966 – the Bloor-Danforth line opened. This was the longest route, stretching eight miles from Woodbine on the east to Keele out west.

In the construction of this line, countless millions of dollars were saved when engineers discovered that provisions for a future subway had been incorporated in the Bloor viaduct when it was built in the teens.

In the past 12 years we have had extensions to the Yonge and Bloor-Danforth routes and, in less than a week, Metro's newest rapid transit route will open with free rides for all. Happy subwaying!

Since the opening of the Spadina subway (as noted in this column) on January 28, 1978, the Bloor-Danforth line was extended (to Kipling Avenue in the west, Kennedy Road in the east) by almost three kilometres on November 22, 1980, and the Scarborough LRT line (Kennedy Road to the Scarborough Town Centre) opened on March 22, 1985. Work is presently under way on the Spadina subway extension.

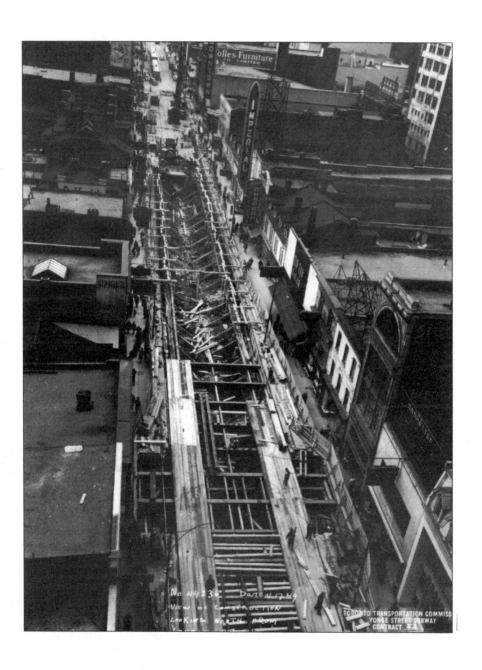

SUBWAY'S DIAMOND ANNIVERSARY

March 30, 1979

Are you sitting down? Because what I'm going to tell you is going to make you feel very old. Today is the 25th anniversary of the opening of the Yonge Street subway. A quarter-of-a-century ago, March 30, 1954, the $66 million, 4.6 mile Yonge line opened with official ceremonies taking place at Yonge and Davisville.

As the first of the brand new red Gloucester subway cars glided downtown on the shiny new tracks, Torontonians were as happy to see the new transit line open as they were to see the end of construction that tore Yonge Street apart for almost five years.

It was September 8, 1949, just days before the ship, *Noronic*, went on fire in Toronto Harbour, killing 119 people, that pile-drivers began their cacaphony at the Yonge-Wellington intersection following a brief kick-off ceremony.

Over the next 55 months, streetcars were diverted, autos and trucks tied up, pedestrians harassed, and storeowners disgruntled.

But it was worth it! It's hard to imagine what Toronto would be like without the Yonge subway, the busiest of the three lines now operating in Metro.

Interestingly, the Yonge line, Canada's first subway and the first subway built anywhere in the world following the Second World War, was actually first proposed at a Board of Trade dinner in 1911 by a local politician with the striking name of Horatio Hocken.

His plan called for a 'tube' under Bay Street swinging over to Yonge north of Davenport and terminating at St. Clair, the then northern city limit.

He also proposed lines under Queen and Bloor streets – the first we're not likely to see but the latter opened some 55 years after Hocken's dinner speech.

Introducing the design of the TTC's new subway trains, 1953.

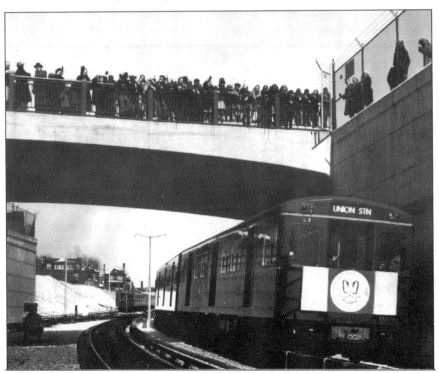

March 30, 1954.

TUNNEL VISION

April 1, 1979

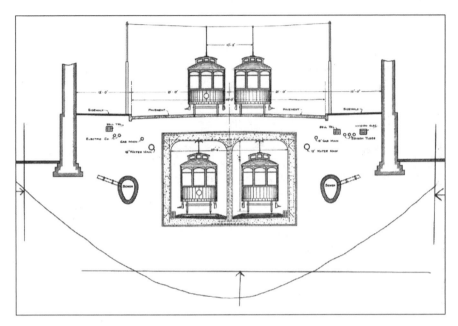

Last Friday was a special day in our city for it marked the 25th anniversary of the opening of the Yonge subway. Although the planning went back to 1944, the initial concept went back even further. A subway for Toronto was first mentioned at the turn of the century, but it was in 1911 that controller Horatio Hocken stated:

> There are many reasons why Toronto should build and operate a tube on Yonge Street. Toronto is notorious for postponing necessary improvements until the cost has doubled or trebled. A rapid transit system must be built eventually and the sooner the better and the cheaper.

This concept had an underground tube running north on Bay Street from Front to Davenport Road, under Ramsden Park to Yonge Street, then north to a terminus at St. Clair Avenue. The equipment was to consist of regular surface streetcars, and the total cost – $5,171,395.

The drawing shows the 1912 consultants' idea of a cross-section of the new subway. Interestingly, Hocken also proposed a similar underground line under Bloor Street from Keele to Coxwell, a line that eventually came into being 54 years later.

TORONTO'S OLDEST HOME

February 26, 1978

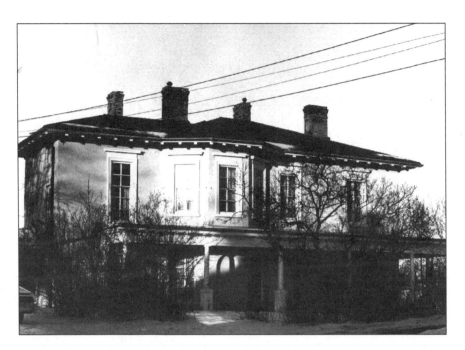

Overlooking the Don River (and the Parkway and the Bayview Extension) just to the northwest of the Bloor Street viaduct, stands Toronto's oldest inhabited dwelling.

Built in 1830 by Frank Cayley, an early resident of our city, the residence is known as 'Drumsnab,' a name taken from an early Sir Walter Scott novel. Originally constructed as a one-storey bungalow, a second floor was added two decades later.

The property on which 'Drumsnab' stands was part of the crown grant awarded to Captain Playter and, before Bloor Street was cut through east of Sherbourne, the entrance to the Cayley home was via a narrow road cut through the dense forest from the top of Parliament Street.

The walls of 'Drumsnab' are of solid stone, two-feet thick. This stone was found on the property surrounding this historic Toronto landmark.

WHEELS OF PROGRESS

February 19, 1978

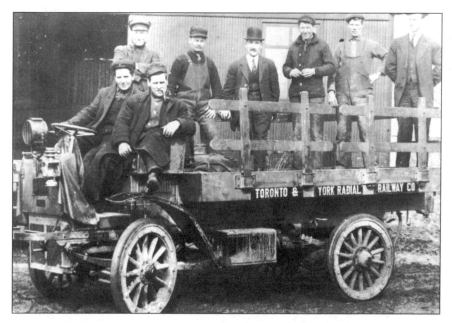

Seventy-five years ago, the vehicles shown in these views were typical of the 'horseless carriages' roaming the streets of Toronto. It's said that the first auto appeared on our streets in 1898, driven by Dr. Percy Doolittle of Sherbourne Street. Four years later the Winton Automobile Company opened a showroom at 126 King Street East. In 1903, May 4 in fact, 27 motor enthusiasts paraded around Toronto, stopping at the Queen's Hotel (now the site of the Royal York) long enough to eat and establish the Toronto Automobile Club, which subsequently became the Ontario Motor League. Any of you car buffs know the make of the two vehicles in the accompanying views?

While the truck remains unidentified, the automobile is a 1903 Winton with W.S. Smith (in the cap) parked in front of the King Street East showroom of the Automobile and Supply Company.

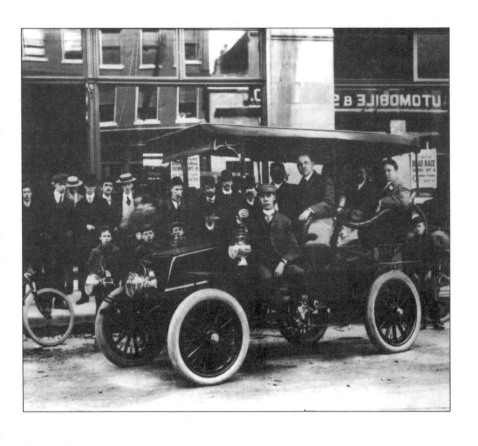

A DEATH GAVE TORONTO THIS MUSIC HALL

April 2, 1978

There's been much in the press recently about our city's 'new' Massey Hall soon to rise on the southwest corner of King and Simcoe streets. But even when the 'new' Hall opens, we will still be able to enjoy the 'old' Massey Hall which is to be renovated by the Board of Governors.

Have you ever wondered why this historic landmark is called Massey Hall?

In 1870, Hart Almerin Massey incorporated the Massey Manufacturing Company which moved from Newcastle to Toronto in 1879, and 12 years later became the Massey-Harris Co. Ltd., the largest manufacturer of farm implements in the world.

Hart's eldest son, Charles Albert, spent much time working in the factory while attending school, and in 1870, at the age of 22, became vice-president and general manager of the company.

In January 1884, Charles appeared to come down with a severe cold. Soon, he contracted viral typhoid from which he never recovered, and died on February 12, 1884.

In memory of his son, the elder Massey built Massey Hall which he gave to his adopted city. Massey Music Hall, as it was initially called, opened on June 14, 1894.

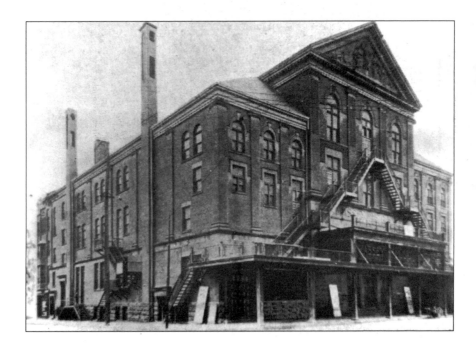

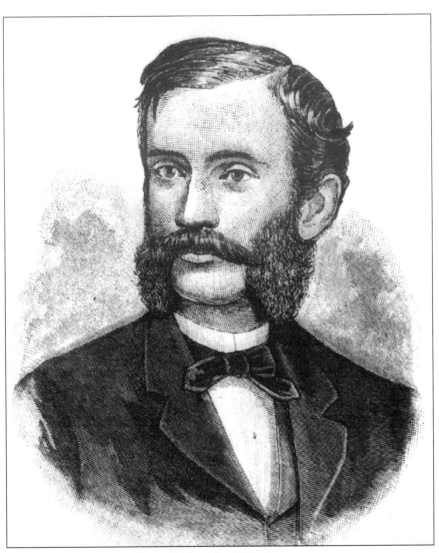

Charles Albert Massey.

MANSION AT KING AND BAY

April 30, 1978

Recently, a reader asked whether I thought anyone would remember the two-storey house that stood for many years on the northeast corner of King and Bay streets in downtown Toronto. The corner is now occupied by the Bank of Nova Scotia's head office.

Shown here is a photograph of that house which was described by John George Howard, donor of High Park and one of our city's finest architects, as "the most beautifully proportioned house in Toronto."

Built in 1852 by William Cawthra, who had a substantial income from the rental and sale of various holdings in the young city, Cawthra House, as it was known, was built of Ohio sandstone, and the fine carvings over the doors were probably done by the same stonemasons who were working on University College.

The history of the property on which the house was built is rather interesting. Originally part of Town Lot 4, granted by Simcoe to Captain Couzens in the late 1700s, the property was first sold in 1800 to E.H. Payson for £20 or about $100! Six years later the same lot was sold again, but by now inflation had driven the price to £100. The new owner, William Knot, sold the land to Sam Rogers for £175 in 1851. The following year, William Cawthra purchased a portion of Lot 4 (53' x 146') for £1300 or $5,850 and immediately had his mansion erected on the site.

Following Cawthra's death in 1880, the mansion was leased by Cawthra's widow to the Molson's Bank (which was to be absorbed by the Bank of Montreal in 1925).

In 1903, the downtown property was willed to Cawthra Mulock, a grand nephew of the original builder, who sold it a year later to the Canada Life Assurance Company for $156,000.

Over the next few years, the sturdy old house became first a Sterling bank (later absorbed by the Standard, itself absorbed by the Bank of Commerce in 1928), then offices, and finally a vacant, empty shell.

Prior to its demolition in the mid-1940s, a proposal was made to move and preserve the house, but the plan died and in 1949 a skyscraper was built on the site.

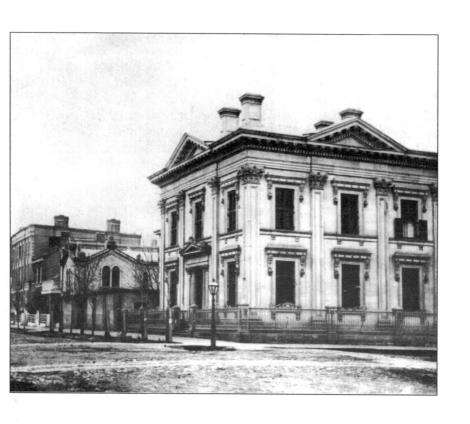

TORONTONIAN DIES IN LINER TRAGEDY

May 7, 1978

Sixty-three years ago today, the Cunard liner *Lusitania*, while making its 202nd crossing of the Atlantic, was torpedoed just south of the Old Head of Kinsale, Ireland. On board the 32,000-ton vessel were 360 Canadians, and for many years arguments raged as to whether some of these were troops.

One of the Canadians on that fateful crossing was Alfred R. Clarke of Toronto. He was president of A.R. Clarke & Company, one of the largest leather manufacturers in the British Empire. Their large factory still stands at 633 Eastern Avenue in south-central Toronto.

When the German U-boat, *U-20*, torpedoed the '*Lucy*,' and she sank in just 18 minutes taking 1201 men, women, and children with her, Clarke was one of the 764 survivors.

After agonizing for hours in the cold Atlantic, he was rescued and hospitalized for a broken rib and shock. After being released, Clarke continued to London where he contracted pleurisy. Again hospitalized, he was treated by another prominent Canadian, Sir William Osler, but died June 20, 1915.

In addition to his leather interests Clarke was a governor of the Toronto Housing Company, one-time president of the Riverdale Businessmen's Association, and director of the Ontario Motor League. While with the OML he chaired a committee that raised money to purchase an ambulance used in France by the Red Cross.

A fine new book has appeared on the market that retells the story of the sinking of the *Lusitania*. *Sail, Steam & Splendour* by Byron Miller is a lavishly illustrated book that helps the reader relive the days of the transatlantic liners.

The tragedy of *Titanic, Lusitania, Isle de France*, and *Andrea Doria*, as well as the exciting years of the floating palaces – *Mauretania, Queen Mary, Queen Elizabeth*, and the *France* – make for exciting reading.

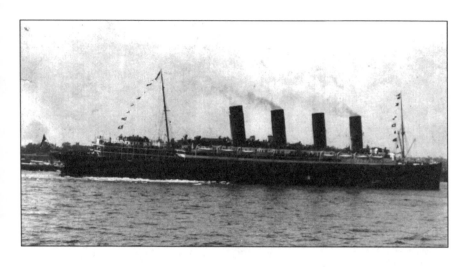

VANISHED MANSION

July 30, 1978

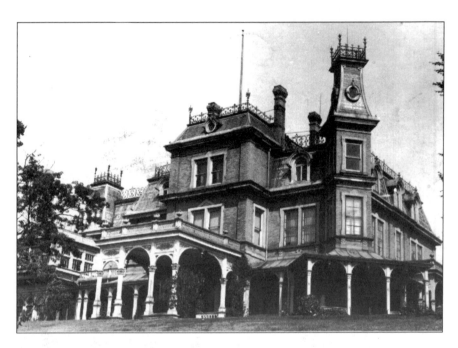

S ituated in the triangular piece of property bounded by Davenport, Poplar Plains, and Russell Hill roads was an estate known as Glenedyth.

One of many such estates that ringed the growing city of Toronto a century or so ago, Glenedyth was the home of Samuel Nordheimer, a Bavarian who came to America in 1839 at the age of 15.

He and his brother eventually moved to Kingston, Ontario, and in the early 1860s again moved, this time to the busy city of Toronto. Here they established a small piano factory at 15 King Street East.

Over the years the Nordheimer Piano & Music Company expanded and the family became extremely wealthy and influential. Samuel became a bank president, a director of the Toronto General Trusts, Canada Permanent, and Confederation Life, to mention just a few titles. He was also, for a time, the German consul for Ontario.

Shortly after becoming established in his newly adopted city, Samuel had purchased a parcel of land from Admiral Augustus Baldwin. It was on this property that he had built, to the design of a famous Viennese architect by the name of Reck, a lovely Victorian mansion complete with spacious halls, wide verandahs, and no fewer than 12 lofty turrets. He called his domain Glenedyth in honour of his bride, Edyth Boulton, a great granddaughter of D'Arcy Boulton, founder of the Grange.

In the 1920s, plans were afoot to retain the house and the surrounding 23 acres of beautifully landscaped property and turn Glenedyth into a public park.

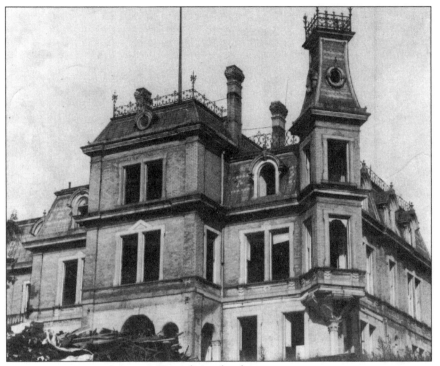

Demolition has begun.

Land prices being what they were (even then $1 million was the estimated purchase price), the estate was eventually subdivided and the present residences built. The mansion itself, shown above in its last days, was demolished in the late 1920s.

OUR CITY'S HISTORY IN STAINED GLASS

May 27, 1978

One of the most magnificent stained glass windows in Canada is right here in Toronto. Located in 'old' City Hall, this window depicts "the union of commerce and industry." It was designed and executed by the Robert McCausland Company, a family-owned business that is still operating in our city and traces its origin to the year 1856. In that year Joseph McCausland established the Canada Stained Glass Works, and several years later his son Robert took over the operation.

In 1884 the younger McCausland prepared a stained glass portrait of Charles Albert Massey which was installed in Massey Hall. A few years later, while doing some work on the Massey Mausoleum, he met the architect Edward James Lennox who was also working on a new City Hall at the top of Bay Street. Lennox asked McCausland to design a window for the main staircase in the new Hall. On February 14, 1898, Robert submitted his idea, which was approved in August. By April of the following year the masterpiece was ready to install. The total price was $1,500!

On the right of the window are views of the 1844 City Hall on Front at Jarvis and the 1899 Hall under construction; the man shaking hands with "Commerce" appears to be a likeness of Joseph McCausland, founder of the company.

Other work by this long-time Toronto company can be found in St. Paul's Church, Casa Loma, and the King Edward Hotel.

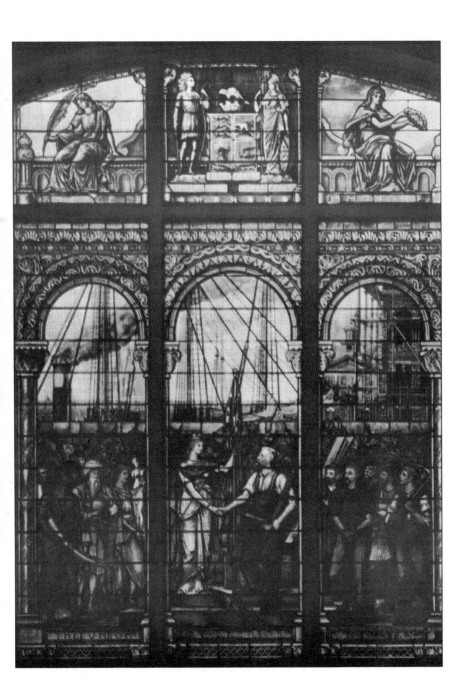

NO NICKEL AND DIME CORNER

June 4, 1978

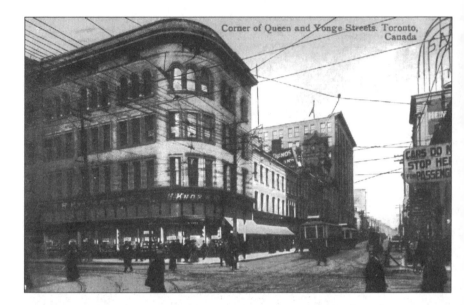

Corner of Queen and Yonge Streets. Toronto, Canada

E ver wondered what the 'F.W.' of F.W. Woolworth stands for? Frank Winfield was born April 13, 1852, in Jefferson County, New York. In 1876 he married Jennie Creighton of Picton, Ontario, and three years later opened his first '5¢ store' in Utica, New York.

Frank's cousin, Seymour Horace Knox, opened a 'five and dime' store in Toronto on April 30, 1897, at the northwest corner of Yonge and Queen streets. Aided financially by the now highly successful Woolworth, Knox ran the store until 1912, when his company along with F.M. Kirby & Co., E.P. Charlton & Co., C.S. Woolworth & Co., and W.H. Moore and Son amalgamated with F.W. Woolworth Co., and that latter name went up on the Yonge-Queen store.

Interestingly, when Frank Winfield Woolworth died in 1919, Hubert Parsons of Toronto became president of the company.

By the way, do you know why the present store still stands while all those around have been demolished for Phase 2 of the Eaton Centre Project? Because the property is owned by McMaster University.

Wonder how long the building will keep standing?

Not only is the 1895 building at the northwest corner of Yonge and Queen streets still standing, the aluminum covering that appears in the 1978 photograph has been removed and the original brick facing beautifully restored. The structure is now home to a bank, various offices, and a fitness club.

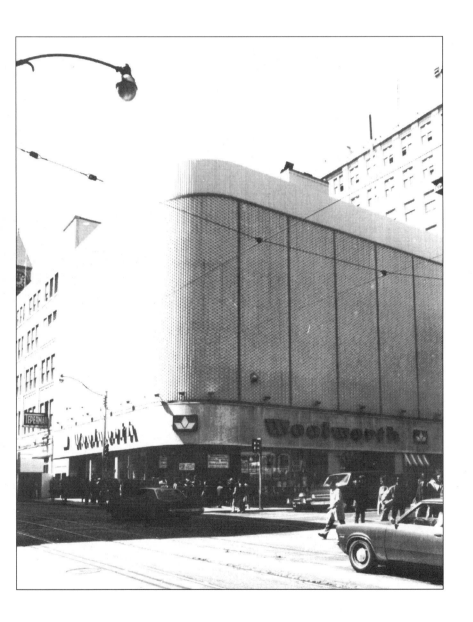

FIRE SCORCHES TORONTO LANDMARK

July 23, 1978

Several weeks ago, fire tore through one of the most historic buildings still standing in our city. Built in 1830 to house the rapidly expanding Bank of Upper Canada, the structure stands at the northeast corner of Adelaide (then Duke) and George streets, just east of Jarvis.

It was to this bank that William Lyon Mackenzie, the mayor, and his colleagues went to obtain £1,000 to start our city's first public works project – wooden plank sidewalks on King Street. The year was 1834, our year of incorporation, and the bank's verdict – no loan! The city would never last.

After the bank folded in 1866 this building became the home of De La Salle boys' school, and the addition to the east was added five years later. The original bank is seen in the photo with the addition which is still identified by wording cut into the stone.

Over the years various commercial enterprises have occupied the historic old building. It remains the oldest bank structure in the province and would make a logical headquarters for the Canadian Bankers' Association.

What must not happen is to allow this vital link with our past to fall into such disrepair that demolition is the only course of action.

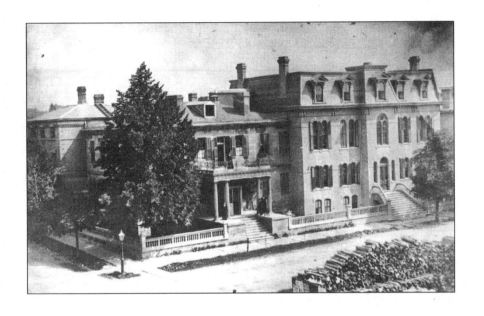

AN OLD BUILDING GETS A NEW LIFE

December 14, 1980

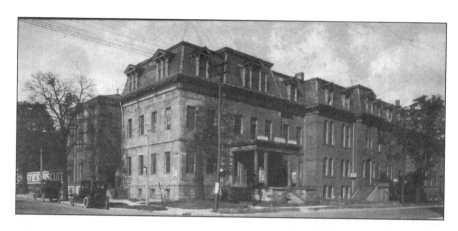

To those of us who are fascinated by our city's history, there's a kind of minor miracle happening down on Adelaide Street. One of Toronto's oldest buildings and, it's believed, the country's oldest banking structure is undergoing a rebirth. Thanks to the efforts of Sheldon Godfrey and his wife, Judy, the collection of buildings at the northeast corner of Adelaide Street East and George Street are being repaired, restored, and reborn.

Let's go for a quick tour. First we'll head for an area that until 1834 was the Town of York. On March 6 of that year, streets such as King, Frederick, Front, Caroline, Berkely, Princess, George, Duke, and Duchess became the main thoroughfares of the new city of Toronto. At the northeast corner of George and Duke (now Adelaide) stood the head office of the powerful Bank of Upper Canada, which had been established as the first bank in York in 1825. Property on which the two-storey, cut-stone structure was erected had been obtained from Chief Justice Sir William Campbell, whose own house stood just to the east and, in 1972, was moved to the northwest corner of Queen and University. The building was designed by a multi-talented man, Dr. William Warren Baldwin who, in addition to dabbling in architecture, found time to practise both medicine and law.

About 1851 an addition to the bank was constructed just behind the 1827 structure and this facility became the chief cashier's (a term now replaced by general manager) residence.

Over the ensuing years the Bank of Upper Canada outgrew the Duke Street premises and in 1861 moved to a larger building on Yonge Street just north of Wellington. A short five years later, a severe depression resulted in the bankruptcy of our first bank. Following the bank's collapse, the provincial government acquired the old buildings and in 1870 sold the property to the Christian Brothers who transformed them into a boys' school known as De La Salle Institute. In 1871

66

the school built a large addition to the east and three years later, in 1874, added a former post office building to the complex.

In 1931, De La Salle Institute moved into the former residence, on Avenue Road, of Senator John Macdonald, 'the Merchant Prince,' and thereafter was known as De La Salle Oaklands, the latter word being the name of Macdonald's estate.

Meanwhile, back downtown, the former bank/school/post office complex had been purchased by the United Farmers Co-operative Limited, which used the buildings for a multitude of purposes until 1956 when the historic structures were converted for use as an egg-grading and packing plant. This latter, rather demeaning, existence for those important buildings in our city's history went on until 1973 when the structures were vacated and left to the elements and transients. In fact, the entire complex was nearly destroyed by fire in 1978.

CITY OF THEATRES

September 17, 1978

There was a time in our city when the four theatres (pictured below) were the "cream of the crop." Of the four shown, only the Royal Alexandra (bottom left) is still with us. Built in 1907 by Cawthra Mulock, the playhouse was saved from certain demolition by 'Honest Ed' Mirvish. Shea's Vaudeville (top left) stood at the southwest corner of Richmond and Victoria and, in fact, became known as Shea's Victoria in later years. The Grand Opera House (top right) was on the south side of Adelaide, just west of Yonge, and was owned for a time by Ambrose Small, the not-too-well-liked millionaire who vanished without a trace in 1919. Rumour had him disposed of in the Grand's furnace. Shown at bottom right is the Princess Theatre which was demolished in the late 1920s when preparations were under way to extend University Avenue south of Queen Street.

Today, Toronto is fortunate to have dozens and dozens of theatres, many of which would boggle the minds of those who knew the Grand, Princess, or Shea's as the latest work in movie houses.

OLD SCHOOL MEMORIES

January 7, 1979

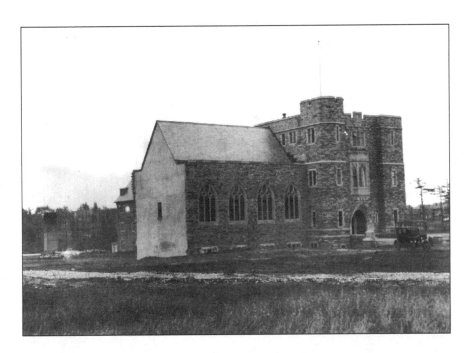

Havergal College opened its doors on September 11, 1894, in a small building at 350 Jarvis Street. The name Havergal was chosen to commemorate Frances Ridley Havergal who had written many religious books, pamphlets, and hymns, several of which are still found in Anglican, Presbyterian, and United Church hymnals.

Within a few short years, the new school had outgrown its small premises, and on Thanksgiving Day, 1898, the students moved into the new Havergal (now the radio building of the CBC at 350 Jarvis Street). The school continued to grow rapidly and, although additional facilities were acquired nearby over the next few years, it was obvious that new, larger quarters were necessary.

In the early 1920s a property called Northdale, 27 acres near the intersection of Avenue Road and Lawrence Avenue, was purchased. A portion of this property used to be the Glengrove Golf Links. On April 23, 1926, the cornerstone for the new school was laid by the lieutenant-governor of Ontario. The school, designed by Chapman & Oxley (Princes' Gates and Ontario Government Building of CNE fame), opened on May 1, 1927.

The photo above shows the original building which has been added to many times over the last 51 years.

BANKS FOR THE MEMORIES

November 5, 1978

The old wooden Yonge streetcar has gone, as has the Board of Trade building on the right in the postcard view of Yonge and Front streets, below. But, it's interesting that three older bank structures can still be seen in the present-day photo (opposite page). The most obvious, of course, is the Bank of Montreal from 1885. Just up the street and showing just over the streetcar is the Bank of British North America at Yonge and Wellington, also from 1885. It's now vacant and I wonder what'll happen to this rather grand bit of Victoriana? Up the street and towering over all (in the postcard view anyway) is one of Toronto's early skyscrapers, the Trader's Bank, which in 1912 was absorbed by the Royal Bank. The building, built in 1905, still stands at the corner of Yonge and Colborne streets.

Both 19th century bank buildings continue to perform a vital service to the community, the Bank of British North America as an office building and the Bank of Montreal as part of the new magnificent new $25 million Hockey Hall of Fame complex that officially opened to the public on June 18, 1993.

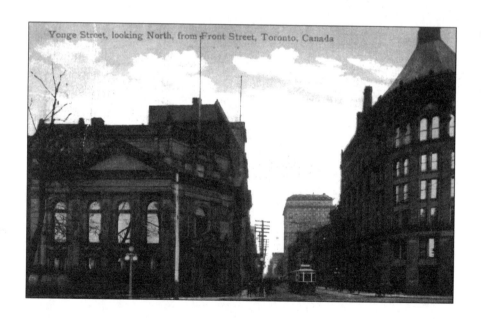

Yonge Street, looking North, from Front Street, Toronto, Canada

I'LL DRINK TO THAT

December 3, 1978

Developed by J.J. McLaughlin (brother of Colonel Sam of General Motors fame), Canada Dry beverages have a very close tie with our city. In 1888, McLaughlin began manufacturing mineral waters and a year later opened a plant and office on Queen Street at Victoria.

In the early 1890s things became so busy another factory was opened at 153–155 Sherbourne Street. The flavours marketed were: ginger ale, lemon sour, cream soda, ginger beer, and, of course, sarsaparilla. In 1905, the name Canada Dry was registered and the map of Canada label introduced.

Canada Dry products were shipped to the States in 1908 and by the mid-1930s Canada Dry drinks were being bottled in numerous plants all across Canada, the USA, and in Lima, Peru. Interestingly, the company introduced soft drinks in cans and dietetic drinks in 1953. Today there are more than 40 flavours bottled in 80 countries on six continents. And it all started in our Toronto, 90 years ago.

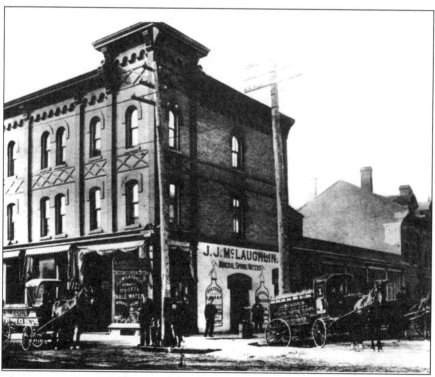

Northwest corner of Queen and Victoria streets.

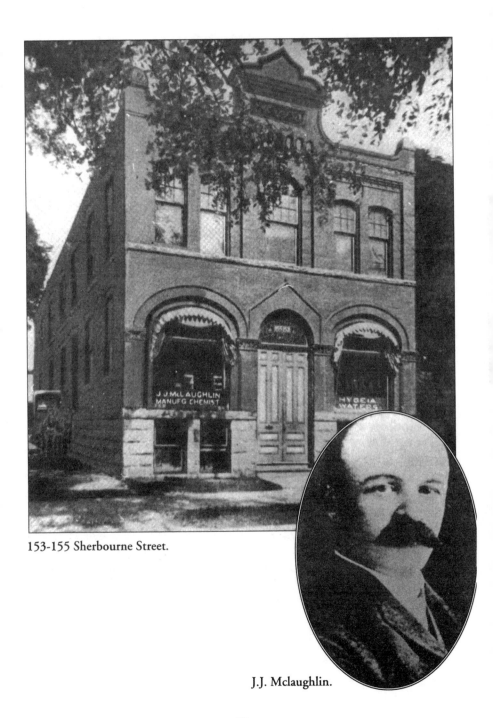

153-155 Sherbourne Street.

J.J. Mclaughlin.

CHILDHOOD RECOLLECTIONS

January 14, 1979

Bloor and Bathurst is a corner I remember very well, although the photo (opposite page) is before my time. I was born in 1941 and although I spent a couple of my earliest months on Tilson Road in North Toronto, my earliest memories are of this area of the city. On the north side of Bloor, just west of Bathurst, I remember Liggett's Drug Store (Ferrah Drugs in photo), Singer's Cigar Store, Downeyflake Donut Shop ("As you go through life, whatever be your goal, keep your eye upon the donut, and not upon the hole"), and, of course, the Alhambra Theatre (I wonder what happened to Pat Tobin, the manager?).

In this photo St. Peter's Church was next to the theatre, but by 1941 it was north of Bloor on Bathurst. On the south side was Loblaw's, Peter's Lunch, and along further, about 1950, a fellow named Ed Mirvish had just opened an upstairs clothing store near the corner of Markham and Bloor.

I also remember the Metro Theatre, Christie Pits, Palmerston School, Ingles' Bicycle Shop, Cooper's Delicatessen, the Midtown, and on and on.

A reader wonders whether anyone remembers a small restaurant located in the vicinity of Eaton's old store at Queen Street. As a young child, he was taken to the Better 'Ole (so named for a First World War cartoon, *Bill and the Better 'Ole*, the latter word a contraction of foxhole) where he remembers seeing soldiers, many of whom were maimed as a result of war wounds. Anyone else remember the Better 'Ole restaurant in downtown Toronto?

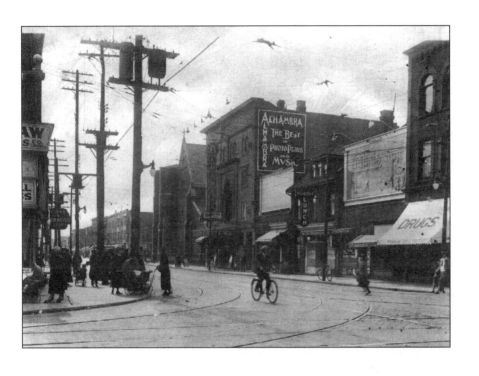

ST. ANDREW'S SECRET

January 21, 1979

Most readers of this column are probably aware that around the top of 'old' City Hall, Edward James Lennox, the architect, had his name, occupation, and date of completion of the building carved into some of the brickwork supporting the eaves. This Lennox did on the 'QT' when his request for a prominently placed plaque was turned down by City Council.

It turns out that another lovely building in Toronto has an inscription carved under the eaves. St. Andrew's Presbyterian Church at King and Simcoe streets has, on the west side, the letters St. Andrews and the date 1875 inscribed on stones as shown in the photograph (opposite page). In addition, various symbols and what appear to be faces also appear. The date 1875 is also significant in that the congregation, which had separated from the St. Andrew's at Carlton and Jarvis streets, held their first service in the new building in 1875.

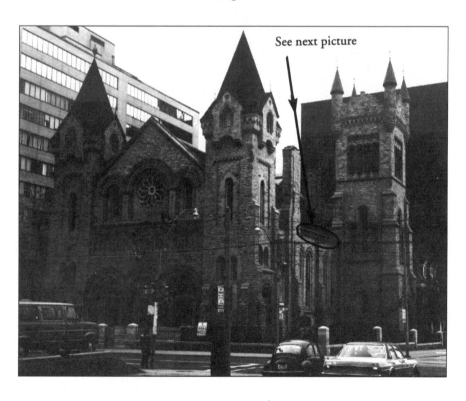

See next picture

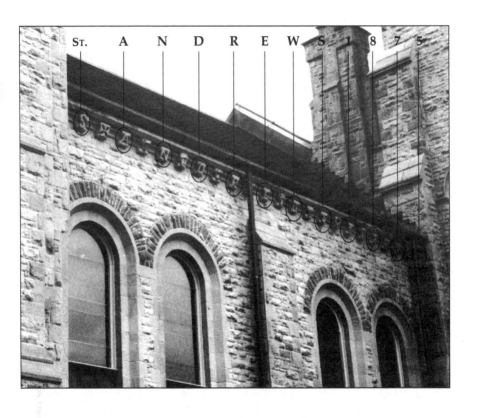

HOTEL FIT FOR A PRIME MINISTER

February 4, 1979

You've heard of topless bars. Well, here's a topless hotel! In an old postcard view taken about 1900, we see the Gladstone Hotel at Queen and Gladstone in all its turn-of-the-century glory, complete with flags and an ornamental roof that has long since disappeared. While the exact date of construction of the hotel is unknown, it is listed in the city directories back when Toronto's western boundary was Dufferin Street and across that street was the town of Parkdale. The hotel was obviously named after the thoroughfare which in turn was named after William Ewart Gladstone, the four-time prime minister of England.

By the way, when you're in the vicinity of the old Gladstone, stop in and have some of Betty's chili in the recently reopened dining room.

Subsequent research reveals that the Gladstone Hotel was erected in 1889–90 and is the work of architect G.M. Miller who is also responsible for the former Lillian Massey Building (now office of the Ombudsman) located on the southeast corner of Queen's Park Crescent and Bloor Street.

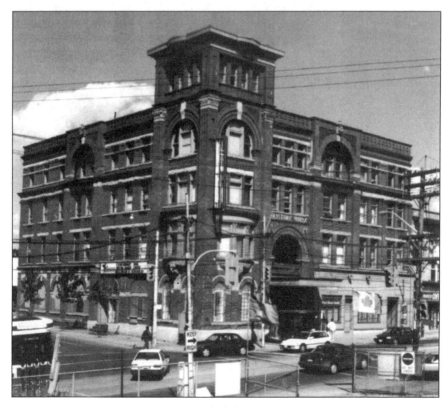

As it is.

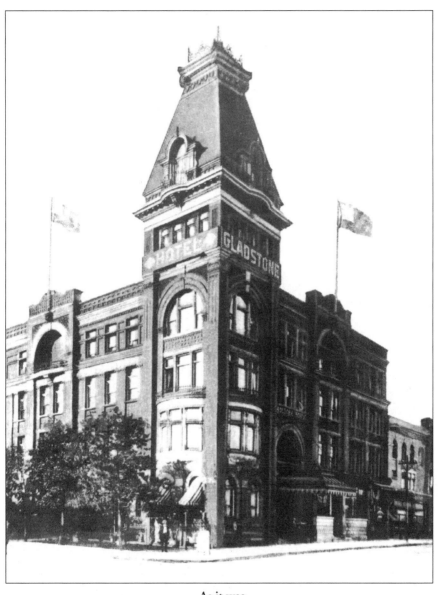

As it was.

EASTER PARADE ON THE BOARDWALK

April 15, 1979

E aster Sunday, 1930. For many years it was a Toronto tradition to stroll the boardwalk at Sunnyside Amusement Park on Easter Sunday. Here we see hundreds of citizens dressed in their new outfits parading the two-mile-long boardwalk that stretched from the Humber River eastward, past the bathing pavilion and the Palais Royale. While Sunnyside didn't officially open until the Victoria Day weekend, some of the largest crowds were in evidence on Easter Sunday. Several attempts were made in the all-too-short history of Sunnyside to remove the boardwalk and lay down a ribbon of cold concrete. As the *Telegram* once editorialized:

> Just what makes two hearts beat in three-quarter time to the rhythm of klunking feet on boards civic officials have no idea, but they are ready to resist efforts to replace the boardwalk with any substitute.

Unfortunately, the editorial wasn't enough and the boardwalk, rides, hot dog stands, and Easter Sunday at Sunnyside vanished in the mid-1950s.

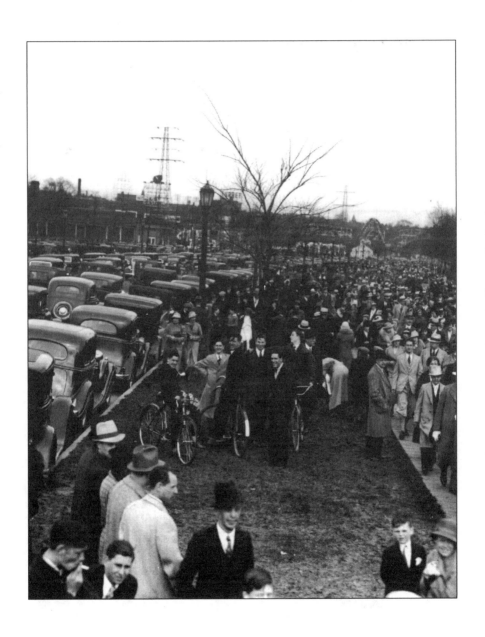

MEMORIES OF SUNNYSIDE

June 24, 1979

The 'playground of Toronto' or the 'poor man's Riviera' opened 57 years ago this coming Thursday. Built on land reclaimed from the old Humber Bay by the Toronto Harbour Commission, Sunnyside Amusement Park got its name from an estate which was located near the present St. Joseph's Hospital owned by the Warden of High Park, John George Howard.

When talking about Sunnyside, memories come rushing back: memories of the Seabreeze Dance Hall, the Palais Royale, Dean's, Downyflake Donuts, Honeydew Red Hots, the Rocket (later called the Flyer), and, of course, the Derby Racer.

The park operated for 33 years before it was ordered demolished by the Harbour Commissioners following several serious fires.

I've often thought there should be a book about 'our' Sunnyside. I'd be interested in hearing from any readers who might have stories they would like to relate about Sunnyside. Please drop me a line, c/o *Sunday Sun*.

Several years after this column appeared, I wrote a book entitled I Remember Sunnyside *which is still available through McClelland and Stewart.*

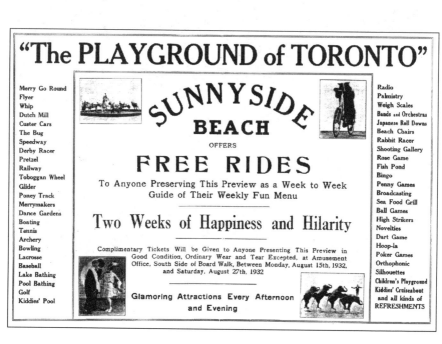

82

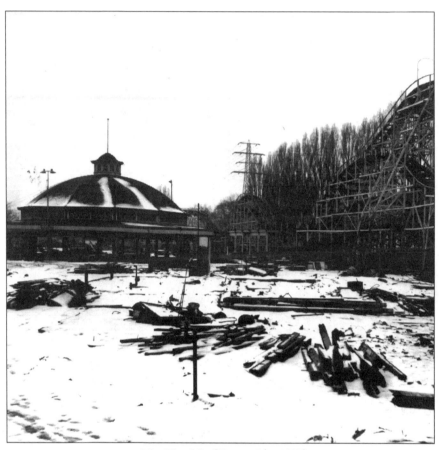

The "death" of Sunnyside, 1956.

DUST OFF YOUR BONNET

April 6, 1980

For many years, participating in the Easter parade at Sunnyside was probably the city's most popular tradition.

Most readers will remember the Easter parade following the Second World War. But it's interesting to note that the Easter parade had been held at Sunnyside since the turn of the century.

Sunnyside Amusement Park opened in 1922 and lasted until 1955 after it was destroyed by a series of fires.

The Toronto Harbour Commission demolished the structures that made up what many people knew as the 'poor man's Riviera.' The name, Sunnyside, however, goes back to the mid-1800s when John Howard, who gave us High Park, built a summer villa on the sunny side of a hill and named it Sunnyside Villa.

Years later Torontonians showed off their new Easter wardrobes by parading along a small wooden boardwalk which had been constructed at the water's edge. (In 1954 the boardwalk, having 11,000 wooden planks, was torn up and replaced with asphalt.)

Following a strenuous day of parading, many would visit Mrs. Myers' restaurant where they could indulge in a fish or rabbit dinner for 25¢. Mrs. Meyers had been a hairdresser on Shuter Street and had traded (pardon this) hair for hare!

Following the demise of Sunnyside Amusement Park, the Easter parade moved to Bloor Street, then to the Beach.

You can don your Easter bonnets and attend the East Toronto Community Association's 14th annual Easter Parade this afternoon at two. The parade route is westward along Queen Street to the Greenwood Race Track.

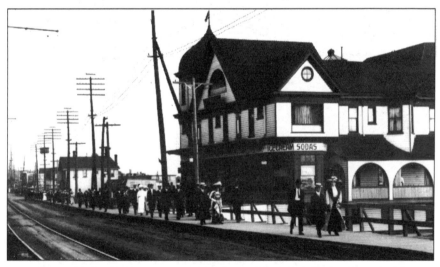

Sunnyside in 1907 ... everyone was there with their bells (and bows) on!

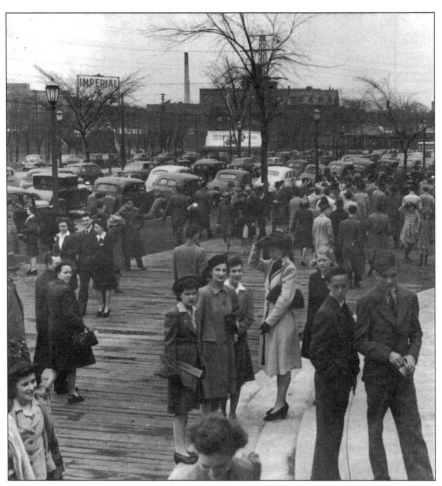

Easter (March 1948) ... a stroll along the boardwalk was a favourite pastime.

FROLIC AT THE PALAIS

June 7, 1981

Constructed in 1921, the Palais Royale was originally Dean's Boat House where Walter Dean and his family built their famous Sunnyside Torpedo Canoe. As the amusement park known as Sunnyside began to develop and attract more and more funseekers, the structure on the south side of the newly widened Lake Shore marginal driveway was renovated to permit dancing on the main floor while the canoe-building facilities moved into the basement. From those sunny days of the early 1920s right up to the present day, thousands flock to the Palais to 'swing and sway,' 'jitterbug,' or 'rock' to the live bands on the 60-year-old bandstand.

Over the years, numerous Canadian and world-famous bands have played the Palais: Ellis McLintock, Jack Denton, Bob Crosby, Fletcher Henderson, Cab Calloway, Jimmy Lunceford, and who can forget our own Bert Niosi?

On Wednesday, June 28th

at 8 o'clock

There will be opened for Toronto's Smart Set a magnificent pleasure palace on Sunnyside Promenade,

The Palais Royale

offering

Dancing, Refreshments and the

Wonderful Midnight Frolic

featuring

Harris and Kimmey

Late stars of Geo. M. Cohan's Broadway success "Mary,

and

Miss Lillian Bernard

Direct from the opening of Chicago's new palace, The Rainbow Garden.

Dancing	Refreshments	Midnight Frolic
8 to 11 p.m.	à la carte.	
10c a dance.	Highest quality	

Come to the Palais Royale and Dance to the Melodies of the Million Dollar Orchestra.

86

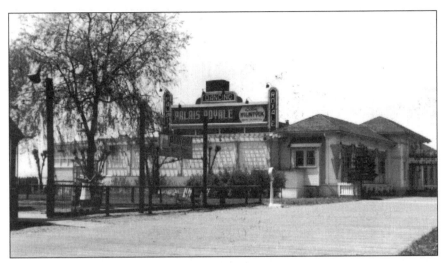

1922.

1981.

REMEMBER THE HUMBER

June 21, 1981

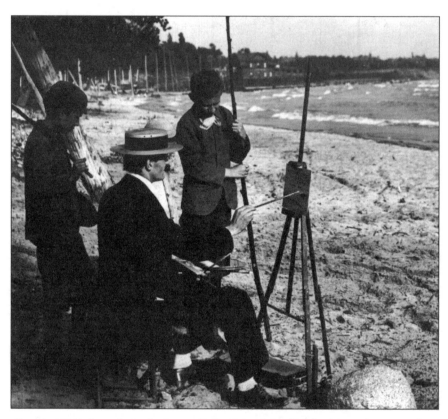

In this 1907 photo from the James Collection of the City Archives, the tranquility of Humber Bay is captured on canvas by artist Owen Staples, accompanied here by two young friends.

Earliest references to what we today call the Humber River refer to it as the Toronto River. This application is easy to understand when one realizes that for as long as there has been human life on the continent, the river was a vital route between the lower lakes and the vast fur wealth of the lakes to the north. Dutch, English and French explorers, and fur traders traversed this carrying place or passage following century-old, foot-worn Indian pathways. Known as the Toronto Carrying Place or Le Passage de Toronto, the term 'Toronto' itself has sparked intensive research which has resulted in suggestions that the name of our beautiful city has been derived from such translated Amerindian phrases such as 'trees in the water,' 'place of meeting,' and 'there are a great many.'

This Toronto River, at least at the lower reaches, was later known as the St. John's River after St. Jean Baptiste Rousseau, a fur trader who is accepted as the first white settler in the Metro Toronto area. Upon the arrival of the first lieutenant-governor of the new British Province of Upper Canada, John Graves Simcoe, the river became known as the Humber after the large river of the same name on the east coast of England that flows into the North Sea. Incidentally a nearby river in South Yorkshire, England, is the Don.

I thought it might be interesting to pretend that we are sitting right here watching the past 365 years of history around the mouth of Humber River unfold in the next few minutes:

In 1615, young Étienne Brûlé was sent by Champlain and his allies, the Hurons, to seek help from the Indian tribes on the Susquehana River. He descended the Humber and gazed upon Lake Ontario – the first white man to do so.

On July 30, 1793, Simcoe sailed by, over there, in his schooner *Mississippi* on his way into Toronto Harbour to establish his new capital, York, now the city of Toronto. On April 27, 1813, six American ships appeared on the horizon and were blown westerly, forcing the attacking landing boats to run ashore near the foot of today's Roncesvalles Avenue.

Seventeen hundred Yankees swarmed ashore. The British and Canadians put up a valiant fight. Dozens were killed. The power magazine was accidentally blown up, there was death and fire all around. The town capitulated and for six days the Stars and Stripes flew over the tiny settlement. The invaders sailed for home on May 2.

Just before the outbreak of World War I, crews began building the seawall in front of the old Lake Shore Road, and soon thereafter Harbour Commission dredges appeared, filling in part of Humber Bay to create a new beach area where rides, concessions, and a lovely bathing pavilion were officially opened on June 18, 1922.

Sunnyside Amusement Park and Bathing Beach was soon attracting thousands. Just up the river on the east bank near the old French fort, the Silver Slipper Dance Hall opened several years later, and in 1927 work began on a half-mile-long amusement pier with theatres, arcades, shops, and dance hall. But only 300 feet and the dance hall of Palace Pier were completed when money and the owners ran out. This landmark burned on January 7, 1963, and several years ago the residential complex we see today arose on the site.

In September of 1954, tiny Marilyn Bell slowly swam towards shore opposite the Ontario Government Building to become the first person to swim the lake. A month later another female was to visit Toronto. This time her name was Hazel. The devastating hurricane caused the usually meek Humber to run wild and the morning after the river and bay were littered with large chunks of homes, half-submerged cats, uprooted trees, pieces of fences, and bodies.

In 1956 work began on the city's waterfront super-highway, and bridges connecting the Queen Elizabeth with the Gardiner Expressway appeared over the river's mouth. The next two decades saw skyscrapers appearing in the mid-1960s and the CN Tower peering over the trees in 1973.

NEW PARK A SON OF SUNNYSIDE

May 24, 1981

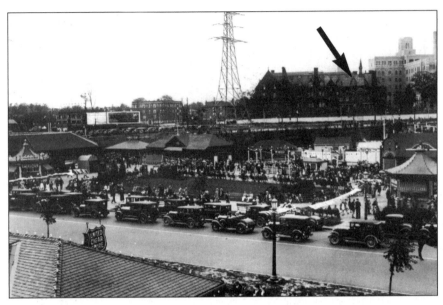

In the photo Howard's villa can be seen (under the arrow) overlooking the amusement park. To the left of the house is Sacred Heart orphanage built in 1885. In 1921, the orphanage became St. Joseph's Hospital, with the 1930 addition shown in the photo to the right of the old villa.

The country's first theme park, Canada's Wonderland, officially opened yesterday. Construction started in April 1979, and 25 months and $120 million later the country's newest family and tourist attraction is ready to welcome an estimated 2.3 million guests.

While Canada's Wonderland is Canada's first theme park, the country has had numerous amusement parks, the direct ancestor of the theme park. Over the next few weeks, in tribute to our new park, we'll look at the most famous of all the local parks, a park that opened 59 years ago – Sunnyside.

The area near the foot of Roncesvalles Avenue has been known as Sunnyside for more than a century. There are two theories as to how the name came about.

The first suggests that John George Howard's villa, which was situated on the site of today's St. Joseph's Medical Centre, was constructed purposely on the 'sunny side' of a hill. The second, a more interesting concept, has as a subsequent owner of the villa, one Henry Speid, a fan of Washington Irving, and the author of such favourite novels as *Rip Van Winkle* and *The Legend of Sleepy Hollow*. Speid is thought to have named his abode after Irving's residence on the Hudson River near Tarrytown, New York, a home known to this day as Sunnyside Villa.

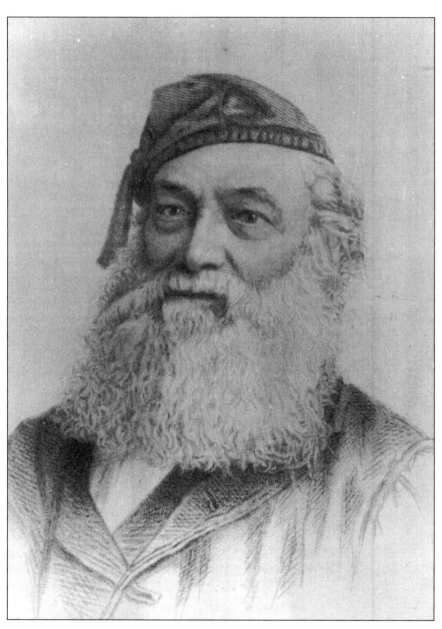

The Santa look-alike is John George Howard, the builder of Sunnyside villa and donor of High Park to the city in 1873.

THE WAY WE BURNED

April 19, 1979 (Thursday)

Seventy-five years ago this evening, the downtown heart of Toronto was devastated by the worst fire ever to visit our fair city in its 145-year history.

Early in the evening of April 19, 1904, as people were settling down to a quiet evening at home, a small fire broke out in the premises of the E. & S. Currie Neckwear Co. at the northwest corner of Bay and Wellington streets.

About 8:00 pm a patrolling constable noticed flames flickering inside the four-storey structure and rang in the alarm on Box 12 at the intersection of Bay and King streets. Within the hour, the conflagration was out of control, and to compli-

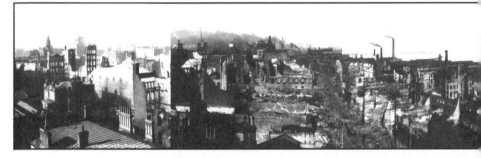

This was the scene viewed along Front Street showing the destruction of the 1904 fire. The photo was taken looking towards the Customs House at Yonge and Front streets. In all, 123 buildings were destroyed.

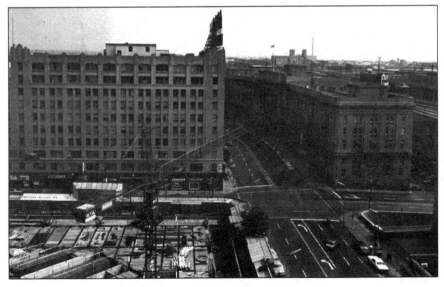

View from the Royal York. New Royal Bank Plaza under construction (bottom left).

Fire apparatus from the CNE firehall, typical of equipment used in fire of 1904.

cate matters the weather took a turn for the worse. Winds from the northwest freshened and it began to snow.

As the first firemen and their rather primitive apparatus arrived on the scene, it became obvious that the blaze was far more serious than first thought. Then, as more hoses were hooked up to the street hydrants, the low-pressure system feeding those hydrants became painfully inadequate.

At the height of the blaze more than 100 buildings in the 19.7-acre area bounded by King, Yonge, the Esplanade, and York streets were burning while 230 firemen did the best they could. Some of these fire-fighters came from communities outside Toronto – Kew Beach, Toronto Junction, East Toronto, and Hamilton. Equipment from Buffalo, Brantford, Niagara Falls, and London arrived by train to assist the stricken city.

By 5:00 the following morning, the fire was officially "under control," but nevertheless, flames continued to erupt from ghastly shells of buildings gutted by the blaze. It was an amazed populace that ventured down on the morning of April 20, 1904. Scarcely believing their eyes, they were overwhelmed by the destruction: 123 buildings destroyed worth $10 million (1904 dollars), 6,000 Torontonians put out of work, and 25 fire-fighters injured (miraculously no one was killed).

All was not a total loss, however. As a direct result of the fire, building codes were modified and, more importantly, the obsolete, low-pressure water system was replaced with the much more efficient system in use today.

Nothing but a few memories of long-time Torontonians and photographs such as those on these pages are left to remind us of that evening 75 years ago when Toronto burned.

BELL–E OF THE EX

August 19, 1979

It's that time again! One of the true traditions in Toronto started for the 101st time last Wednesday. The good old Ex enters its second century, welcomed by the public, scrutinized by the politicians, and loved by everyone.

Remember the CNE, a quarter-of-a-century ago? The year, 1954, and headlining the grandstand show were Roy Rogers and Dale Evans. In those days, the 'Ex' was only on for two weeks; in 1954 it ran from August 27 to September 11.

Marilyn and Toronto's famous singing group The Four "*Standing on the Corner*" Lads.

The 'Ex' management had arranged to have American swimming champion Florence Chadwick swim Lake Ontario from Youngstown, New York, to the CNE waterfront for a prize of $10,000. After several days, Florence entered the lake at 11:06 pm on September 8.

Exactly one minute later, two other swimmers entered the water, both on their own and both without any assurance that the CNE would even recognize them

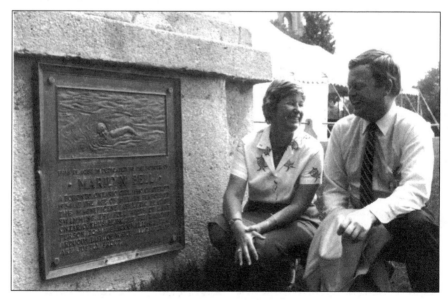

Marilyn Bell and Mike Filey.

should they, by some miracle, complete the swim. Within a few hours Winnie Roach Leuszler was taken from the lake, exhausted, but the other two continued on towards the Canadian side. Then at 4:45 am Florence Chadwick, too ill to continue, was pulled from the water. Only 16-year-old Marilyn Bell was left slowly churning through the 65°F water.

By noon she had passed the eight-mile marker, and three hours later the Bank of Commerce and Royal York Hotel were in view. But suddenly sheer exhaustion overwhelmed Marilyn and she stopped swimming. While her parents silently wished she'd ask to be taken out of the water, her coach, Gus Ryder, quietly called to Marilyn, reminding her that the kids at the Lake Shore Swimming club were counting on her. Once again Marilyn's stroke picked up and at

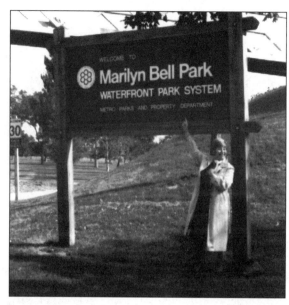

8:03 pm, September 9, 20 hours and 57 minutes after entering the lake (and 25 years ago this year), Marilyn touched the breakwall just south of the Ontario Government Building (now Carlsberg Festival).

This city, the country, went wild! Marilyn Bell became an instant heroine. As a result of her courageous effort to become the first person to swim unfriendly Lake Ontario, gifts began to pour in – a blue Austin convertible, a black and white TV, cases of Orange Crush, a budgie, bushels of apples, and so on. The next year saw Marilyn back at the CNE, this time as a special guest on the gigantic grandstand stage where she was introduced by Ed Sullivan, an American who'd MC'd the "Canadiana" stage show.

In these photos we see Marilyn who appeared at the 1955 grandstand show with the Four Lads, and the plaque erected on the base of the lion monument at the Ontario Building overlooking the spot where Marilyn came ashore dazed, but triumphant, a quarter-century ago.

Several years after this column appeared, I met Marilyn when she came to Toronto to officially open the 1984 edition of the Canadian National Exhibition. Not only was that year Toronto's 150th anniversary of incorporation, but it was the 30th anniversary of Marilyn's epic swim. While chatting about that swim I discovered that she actually completed the historic crossing when she touched the breakwall south of the Boulevard Club, a spot that's nearly two kilometres west of the CNE plaque that appeared in my column. During that 1984 visit to Toronto, the small park located south of the Exhibition Grounds was renamed Marilyn Bell Park in tribute to this distinguished former Torontonian.

REUNITING MARILYN WITH THE *MONA IV*

November 3, 1985

Several weekends ago I had the pleasure of going on a short trip aboard a vessel which, for several hours on September 8 and 9, 1954, was part of one of the most spectacular stories ever witnessed by this city.

Late in the evening of September 8, 31 years ago, 16-year-old schooolgirl Marilyn Bell waded into the cold waters of Lake Ontario just off Youngstown, New York, to start her gruelling 20 hour and 57 minute conquest of the lake. She swam 32 miles from the mouth of the Niagara River to the Toronto shoreline at the Palais Royale dancehall.

Her pace boat for that

Marilyn Bell Di Lascio meets the *Mona IV*'s new skipper, Cecil Crealock, during a visit to Midland in October.

historic event was the *Mona IV*, which I 'found' several months ago in Midland Harbour. While I say 'found,' the *Mona IV* was never really lost, just misplaced.

Many thought the boat had been scrapped after a fire seriously damaged her in 1959, but reader Jack Russell, who piloted the small skiff just a pole's-length away from Marilyn, wrote to say he thought the vessel still might exist in Penetang.

A visit to that community in Huronia revealed the *Mona IV* did indeed live on, but several miles to the east in Midland. A short drive later I met her skipper, 83-year-old Cecil Crealock, his son Fred, and Fred's girlfriend, Diana.

After a quick tour I promised to return later in the year when Marilyn (Bell) Di Lascio was to be back in Toronto to do research on her biography. So it was on Thanksgiving Sunday that Marilyn and the *Mona IV* were reunited.

Almost as much fun as seeing Marilyn and the *Mona IV* together again was chatting with 83-year-old Cecil Crealock, who was able to give me much of the history of his pride and joy.

Mona IV was built in 1929 at the Gidley Boat Works in Penetang for E.A. Rogers, who two years earlier had put his radio station, CFRB, on the air. While I

96

haven't been able to confirm it, it's believed Rogers named his new craft the *RB*.

Following Roger's untimely death in 1939, the 52-foot-long, 40-ton vessel was acquired by the Creed family (of Creed Furs) and later by Dr. Bernard Willinsky, a prominent and popular physician whose practice was located at 604 Spadina Avenue. The doctor renamed the vessel *Mona IV* after his wife. *Monas I, II,* and *III* were the doctor's racing boats.

Willinsky was a good friend of the *Toronto Star*'s Harry Hindmarsh, whose newspaper sponsored Marilyn's lake swim. When the request went out for a large, well-equipped boat to accompany her, 'Bunnie' Willinsky stepped forward and offered the *Mona IV*.

Thus it was that the *Mona IV* became part of Toronto history. Shortly after the doctor's death in 1970, the vessel was purchased by family friend Crealock.

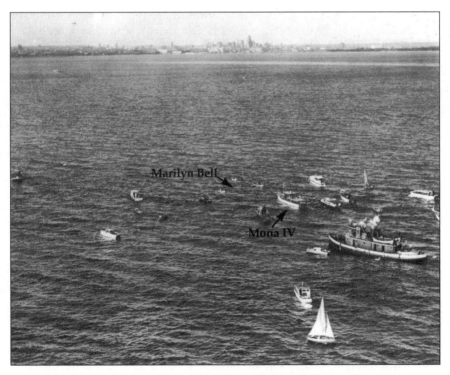

Mona IV stands by as schoolgirl swimmer Marilyn Bell nears Toronto on September 9, 1954.

TO SERVE AND PROTECT

July 29, 1979

In the beginning, law and order in the Town of York (as our city was called from 1793 until 1834) was the responsibility of the High Constable, who appointed special constables as the need arose. Following the change in status from town to city on March 6, 1834, it was deemed necessary to appoint five full-time constables who would be answerable to the high bailiff and city magistrates. In addition to the five full-time officers, 14 citizens were appointed as 'part-time' policemen to be available when needed. This occurred in 1835.

The next major change in the administration of justice came 29 years later when, in 1859, the control of the police department was taken out of the hands of the local politicians and placed under the jurisdiction of a Board of Police Commissioners which consisted of the mayor, a police magistrate, and a recorder. In this same year the total complement of the TPD (Toronto Police Department) was 60 full-time officers. Today, the Metropolitan Toronto Police Department (formed in 1957) consists of more than 6,600, including 4,126 constables and 90 policewomen.

In 1886 a small booklet was prepared by the department outlining the qualifications and the benefits of a Toronto policeman. They make interesting reading nearly a century later:

1. age - under 30 years
2. height - 5ft. 10in., without shoes
3. must be a first class citizen in every respect
4. must pass an examination in reading, writing and arithmetic
5. Pay - 3rd class: $1.35 per day, 2nd class: $1.60 per day, 1st class: $1.90 per day. Detectives & Sergeants: $2.55 per day, Inspectors: $2.90 per day
6. Vacation: officers: 14 days annually with pay, constables: 10 days annually with pay

In the accompanying photograph we see men of No. 4 station which was located on the north side of Dundas, east of Parliament Street. The year was 1886. It was in that same year that the fourth annual police games were being held, a tradition which is to be held for the 97th time on August 11 at CNE Stadium. As part of the evening's show, 'Miss Toronto' will be selected, the 43rd time such a contest will be held as part of the police games.

For an evening of fun and entertainment, why not attend the Police Games on August 11 at 8:00 pm down at the Exhibition? It's only $4 for adults and youths are a dollar. Tickets available at any police station and at the stadium. See you there!

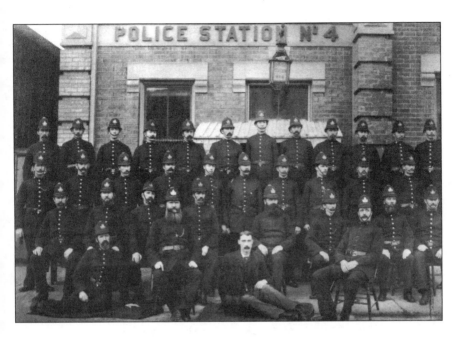

For various reasons, the police-sponsored Miss Toronto contest was cancelled following the 1991 Police Games.

AN OLD INVENTION AHEAD OF ITS TIME

September 23, 1979

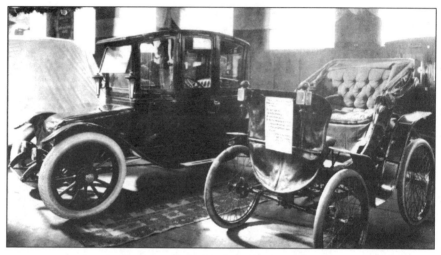

Fetherstonhaugh's electric car at right.

Pictured here (opposite page) is one of Canada's cleverest inventors, and at a time when a frantic search is on for an alternate source of energy, his invention of 1893 is even more interesting today.

Frederick Barnard Fetherstonhaugh was born in Paisley, Ontario, in 1863, and educated in Toronto. He was called to the bar in 1889 and in the following year established the firm of Fetherstonhaugh and Co., Patent Barristers and Solicitors. It was just three years after commencing in the patent business that he was approached by a Toronto typewriter serviceman by the name of William J. Still, who worked on the second floor of a shop at 87 King Street East. Still had invented a lightweight, highly efficient electric storage battery.

Soon Fetherstonhaugh had worked out an agreement whereby he and Still would build an electric-powered 'horseless carriage' with Fetherstonhaugh putting up the money and some of the inventiveness and Still developing a motor powered by a storage battery. One of the reasons that 'FB,' as he was known, became so involved in Still's discovery was that he had a great belief in the future of electricity and, in fact, had one of the first homes in the Toronto area (Lynne Lodge at today's Lake Shore Road and Royal York Road) lit by this 'miracle' known as electricity.

In 1893, Fetherstonhaugh commissioned John Dixon's carriage works at the northeast corner of Bay and Temperance streets to build him a 'horseless carriage' using Still's propulsion system and Fetherstonhaugh's own design. The electric car had several innovative features now found on most modern automobiles – electric lights, pneumatic tires, and rear drum brakes, and featured the world's first folding top, making it what would today be called a convertible. Still's battery/motor com-

bination consisted of a 12-cell battery and a 4 hp motor allowing the vehicle to travel for about one hour at 15 mph.

Power to recharge the auto's battery was 'stepped down' from the current one used to power the streetcars of the Toronto and Mimico Electric Railway that ran from Sunnyside to Mimico Creek.

Fetherstonhaugh's electric vehicle, the first in North America, was featured at the 1893 Toronto Industrial Exhibition (now the CNE), and was also a feature of Toronto's first automobile show in 1906. Although the vehicle has been lost to history, next week we will look at Canada's first motor vehicle company which was a direct result of Fetherstonhaugh's invention.

Frederick Fetherstonhaugh had a better idea.

UNDER THE ROYAL ARCHES

October 7, 1979

The year was 1901; the date, October 10, 78 years ago, and Torontonians were eagerly awaiting the arrival of their majesties, the Duke and Duchess of Cornwall and York (who upon the death of Edward VII in 1910 were to become King George V and Queen Mary).

Crossing the Atlantic Ocean on HMS *Ophir*, the royal couple arrived at Quebec City on September 16 and visited Montreal on the 18th, Ottawa on the 20th, and Winnipeg, Regina, Calgary Vancouver, and Victoria on the 26th, 27th, 28th, and 30th, and October 1, respectively.

Their cross-country tour was on board a special royal train built by CPR and consisting of engine, tender, and nine coaches. The royal entourage arrived in Toronto on October 10 at 2:00 pm, and their visit consisted of a royal procession through the streets, dinner at Government House, a concert at Massey Hall, and a military review at the Exhibition Grounds on October 9, followed by a reception at the Parliament Buildings.

The couple left early in the morning of October 12.

Shown in the accompanying photos are two arches which were constructed at intersections where the royal procession would pass under the structures.

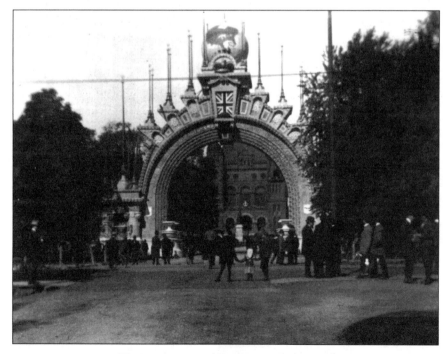

The structure straddles University Avenue

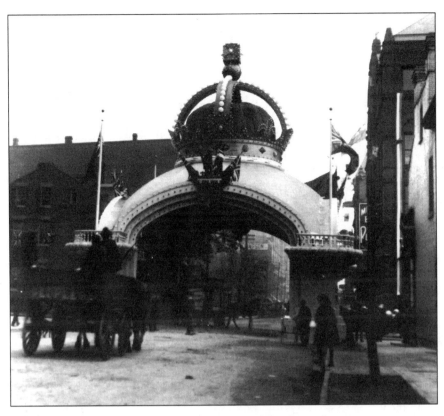

Paper-mâché was the material for this arch.

Above (right) is the Independent Order of Forresters' arch at the corner of Bay and Richmond streets. It is said that much of this structure was made of papier-mâché and, in fact, there are pictures of this same arch on display at the CNE Grounds for several years after the royal visit in 1901.

The other view (left) shows the arch straddling University Avenue just north of College Street. Emblazoned on the arch are the words "Toronto manufacturers hail and welcome you." In the background are the Parliament Buildings in Queen's Park.

THIS STORY'S A REAL GAS

November 4, 1979

One hundred and thirty-one years ago, a company called Consumers' Gas was established. It was called 'Consumers' because those agitating for the company's formation were consumers of gas for heating and lighting their factories and shops. These consumers were fed up with price increases passed on to them by the privately owned supplier, the Toronto Gas, Light & Water Company, which had been supplying gas since 1841.

Initially, Consumers' Gas used the gas manufacturing plants of the private company which they had purchased, but soon, new plants were constructed.

Many of these buildings still stand and have, in some cases, been restored and now lead new lives. You can see some of these fortress-like structures on Eastern Avenue, just east of Broadview (Station B), and near the intersection of Front and Parliament streets (Station A). Nothing but some old walls remain of Station C at Bathurst Street opposite Front Street.

In those early days Consumers' Gas Company customers were supplied with what was known as manufactured gas, since the gas was, in fact, manufactured by burning coal, thereby releasing coal gas and a byproduct, coke, which was much sought after by Torontonians as a source of heat during the winter months. Stations A, B, and C were the manufacturing plants for the gas and were strategically located to serve the customers who used gas for cooking, lighting, or heating.

Some long-time Torontonians may remember the large cylindrical gas holders with the floating roofs. As gas was manufactured the roof would rise, and as the gas was used the roof would drop preventing the metal structure from collapsing due to the vacuum created internally.

Twenty-five years ago this coming Thursday (November 8, 1954) natural gas piped in from Texas and Louisiana arrived in Toronto replacing the manufactured gas. On October 27, 1958, natural gas from Western Canada began flowing into Metro.

Today, more than 600,000 customers from Niagara Falls to Ottawa depend on natural gas for light and heat.

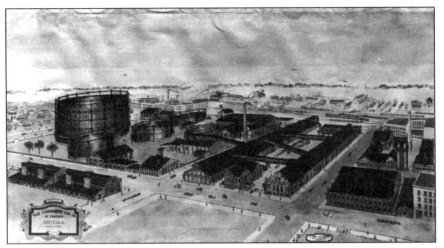

Consumers' Gas complex at Front and
Parliament streets in 1923.

PUTTING OLD TORONTO TO THE TEST

December 23, 1979

Seasons Greetings! For a change of pace, let's have a quiz. The following group of questions will test your knowledge of our city and in some cases how well you've read the past years' "The Way We Were" columns. Let's go; easy ones first.

1) The *Trillium* is:
 a) the official Ontario flower
 b) a million million
 c) a restored 1910 ferry boat
 d) a street in Etobicoke

2) Toronto's sesquicentennial will be celebrated in what year?

3) This amusement park on Toronto's waterfront opened in 1922 and was closed 25 years ago next year? (P.S. Watch for a new book)

4) A Peter Witt, a PCC, and a CLRV have what in common?

5) Where was Gallow's Hill and why was it so called?

6) Can you identify the area in the above photograph from the City of Toronto's archival collection?

7) This major Toronto thoroughfare was named for a brewmaster whose establishment was located in a ravine east of the new Metro Reference Library. Here's a clue – the street used to be called the Sydenham Road.

8) What was the penalty handed out in 1798 to poor John Sullivan for passing a forged cheque for three shillings, nine pence?

9) Why is there a pronounced jog in Yonge Street just north of St. Clair Avenue while the rest of the thoroughfare is dead straight?

10) What is incorrect about this statement? The Lord Simcoe is a large Toronto hotel.

11) King Street was named by Simcoe for King George III who reigned over the Empire when Toronto was first established. Queen Street was named for his wife. True?

12) What do the following Toronto landmarks have in common? 'Old' City Hall, the King Edward Hotel, and Casa Loma.

13) Where is Toronto's only square manhole cover and why is it square?

14) The two sombre-looking gentlemen shown below have two prominent thoroughfares in our city named after them. Who are they and what are the streets. Here's a hint, the streets run north off Queen in the west end and the two fellows were prominent English statesmen who both became prime ministers. Easy!

Answers on next page

ANSWERS

1) Both (a) and (c) are correct.
2) Celebrations marking our city's 150th anniversary will take place in 1984.
3) Sunnyside.
4) They are all streetcars that first ran on Toronto streets in 1921, 1938, and 1978, respectively.
5) The hill on Yonge Street south of St. Clair was the shoreline of prehistoric Lake Iroquois. In the early 1800s a tree that had been struck by lightning stood near the top of the hill. The damaged limbs resulted in a tree that looked from a distance like a gallows.
6) Bathurst Street looking north at Claxton Boulevard in the early years of this century.
7) Bloor Street, named for Joseph Bloor.
8) John was hanged for his indiscretion, the first hanging in our city's history.
9) When the road was being surveyed in the late 1700s, two survey parties started at opposite ends of the prepared military and trade route. As they approached each other it became obvious they weren't going to meet and a 'slight alteration' between Concession 3 and 4 (St. Clair and Eglinton) was made.
10) There are two fallacies:
a) The hotel is no more.
b) John Graves Simcoe, the first lieutenant-governor of our province, was never elevated to the title of 'Lord.'
11) False. Queen Street was originally named Lot Street as the park lots given to the chosen few fronted on the street and ran north 1¼ miles to the Second Concession or Bloor Street. The name was eventually changed to commemorate Queen Victoria.
12) They were all designed by Toronto architect Edward James Lennox.
13) It's located just north of the Queensway on Roncesvalles Avenue beside the Edgewater Hotel. It's square because it had to fit between the streetcar tracks leading into the car house.
14) The fellow on the left is Benjamin Disraeli, Lord Beaconsfield, while the other is William Ewart Gladstone. The streets – Beaconsfield and Gladstone. How'd you do?

A FINE HOTEL FOR SIX DOLLARS A DAY!

February 17, 1980

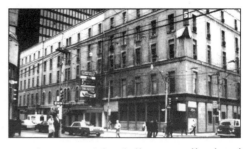

Reader Virginia Marshall wants to know if I can give her any information about the Rossin House, the name of the hotel listed on a bill which she recently found. As a matter of fact, Mr. and Mrs. Palmer stayed for six days in Room 179 in one of Toronto's finest hotels. Six dollars a day (including meals) was a fairly substantial sum in the 1880s (this bill is actually dated September 26, 1883), as was wine at 50¢ a bottle.

The hotel was constructed in 1857 by the Rossin brothers, two local jewellers, on the site of a wheatfield at the southeast corner of King and York streets. In a booklet published in 1858 it's stated that the Rossin House "superceded and shut-up nearly the whole of the other first class hotels of the city," and it was "among the chief architectural ornaments of the city; the hotel being five stories in height, faced with white pressed brick and costing 55,000 pounds ($275,000) for land and building."

The hotel was destroyed by a savage fire in November 1862 and rebuilt the following year when it was operated by one Dr. Chewett. In 1876, proprietorship was turned over to Mark Irish whose name appears on the bill. He ran the establishment until 1888 when Alexander and Abner Nelson took over.

In 1909, the name was changed to the Prince George Hotel, which is the name by which many Torontonians knew it until demolition in the early 1960s when the TD Centre, the first of the 'new wave' of skyscrapers, appeared on the city skyline.

Interestingly, at one period the corner of King and York streets was called 'hotel corner' as there were hotels on all four corners – the Rossin House (later Prince George), Iroquois (Metropole), Palmer, and Shakespeare. The latter hotel was replaced in the 1950s by the Lord Simcoe, which itself is about to be torn down.

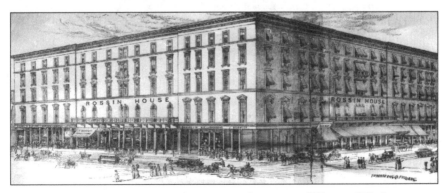

The Rossin House as it was in the 1880s at the corner of King and York streets.

ANOTHER MILESTONE FOR TORONTO!

March 2, 1980

Y ou're not getting older, you're getting better. And in the case of our birthday celebrant this coming Thursday, this saying is especially true.

On March 6, Toronto will celebrate its 146th birthday and plans are well under way to make the city's century-and-a-half party in 1984 something really outstanding.

The map depicts Toronto in its year of incorporation, 1834. In it we see the Island which until 1853 was, in fact, a peninsula. East of the bay was largely marshland which today is known as the Eastern Harbour Terminals, site of coal yards, oil distribution farms, and the Hearn generating station.

Surrounding the city proper was the Liberties, a kind of suburban growing area soon to fill with communities such as Seaton Village (Bloor and Bathurst), Yorkville (Yonge and Bloor), and Macaulay Town (Bay north of Queen).

By 1834, the city streets increased in number considerably from the original 10 in the Town of York as laid out in 1793. Two of the original streets intersected at what was called the 'Royal Corner.'

King Street commemorated King George III who was the reigning monarch when Simcoe founded his new capital on the north shore of Lake Ontario. Now spelled Princess, the intersecting street was originally Princes, referring to the many sons of George III.

Carved in the cornerstone of the building at the southwest end of this 'Royal Corner' is the following inscription:

ROYAL CORNER the ROYAL LAW
If ye fulfil the royal law according to the scripture "Thou shalt love thy neighbour as thyself," ye do well.

James 2:8.

Happy Birthday, Toronto!

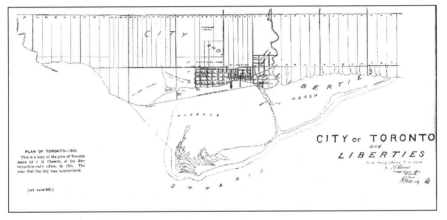

A map of Toronto in 1834, the year of its 'birth.'

END OF THE AIRSHIP ERA

August 10, 1980

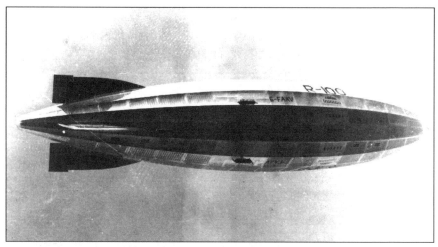

The giant *R-100* airship hovers aloft.

Fifty years ago tomorrow, most of Toronto's 621,596 citizens gazed skyward as the British dirigible *R-100* soared majestically overhead.

R-100 had been constructed a year earlier and was the state of the art in the development of a lighter-than-air ship. She left Cardington Aerodrome on July 29, 1930, and 46 hours, 27 minutes later was over the Canadian east coast en route to Montreal.

Thousands turned out at St. Hubert to watch *R-100* moor to the huge tower. On August 10 at 6:00 pm she left Montreal on a trip that was to show off the mammoth airship to the citizens of Ottawa, Hamilton, Niagara Falls, Brockville, Cornwall, and to Torontonians in the Queen City where the 709-foot *R-100* appeared at mid-morning on August 11, 1930.

The great airship was scheduled to make a return trip to Canada the following year but the tragic crash of the sister-ship, *R-101*, in 1931, while returning from India, not only cancelled the planned return, but ultimately led to the scrapping of *R-100*.

In these views we see *R-100* (above) from directly below showing the engine cars, each housing two Rolls Royce 'Condor' engines. The *R-100* (the opposite page) floats majestically behind the year-old Royal York Hotel.

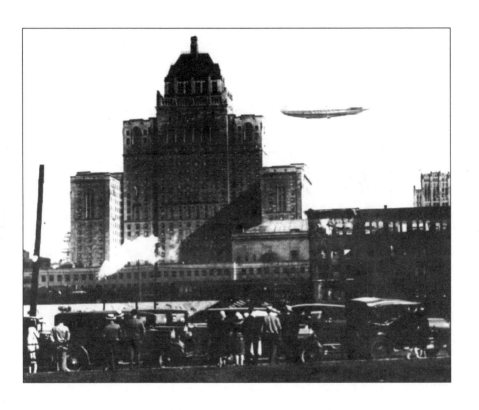

HIGH-FLYING HARBOUR CRAFT NOT SO NEW

August 24, 1980

A recent letter to the editor from reader Harry Rowe prompts a further look at Toronto's waterfront of many years ago. While it is correct that the present fleet of hydro-foil passenger vessels are the first such craft to speed from Toronto to ports across the lake, more than 50 years ago a much different type of 'flying air boat' went into service.

On July 15, 1929, the wife of Premier Howard Ferguson christened the Sikorski amphibian flying boat *Neekah* in a brief ceremony at the city's new temporary air harbour that was located at the foot of Scott Street, an area now covered by Queen's Quay.

This air harbour was temporary in that work was anticipated to start soon on the New Island Airport, this latter facility known more correctly as the Port George VI Airport. The Scott Street facility was initially used as the point of origin for air mail service to Buffalo and Detroit. In 1934 Capreol and Austin Airways operated an air taxi and charter service, and frequently acted as the connecting airline from Toronto to Buffalo feeding the Great American Air Transportation System as one of the early airline services south of the border.

In one photo (opposite page) we see the official party awaiting the *Neekah* to roll up on shore where the christening was to take place. In the right background is the C.S.L. lakeboat *Kingston* moored at a pier which is now the site of the Harbour Castle Hotel.

The picture below shows one of Austin Airways' biplanes as it taxis up to the ramp in 1934. On the skyline, the Royal York Hotel and Bank of Commerce dominate the skyline of 46 years ago.

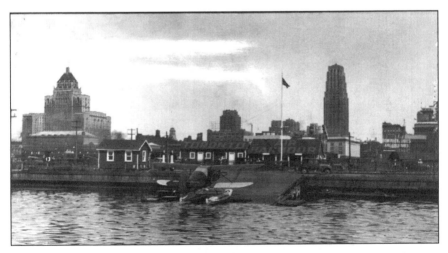

One of the smaller air taxis of the day.

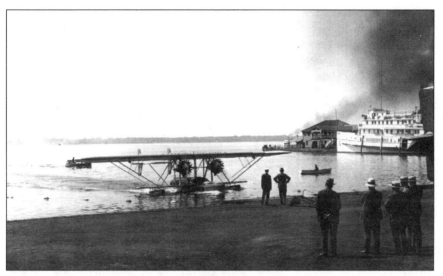

The enormous flying boat *Neekah* is greeted on arrival in Toronto.

THE 'SAN' ONE OF THE OLDEST HOSPITALS

October 12, 1980

Set in 26 acres of park, West Park Hospital won a design award.

A quick glance at the Metro Toronto telephone book reveals there are more than 60 hospitals of one kind or another serving the needs of our citizens.

One of the oldest, yet perhaps least known, is a facility now known as West Park, first conceived in 1898 as the Toronto Hospital for Consumptive Poor. The purpose of this hospital was straightforward – to provide comfort and care for those afflicted with 'the white plague' or consumption. More recently the dreaded disease became known as tuberculosis.

Two years earlier in 1896, Toronto publisher William Gage and several associates formed the National Sanitarium Association and opened a sanitarium in Gravenhurst to treat 'paying' patients who had contracted the disease which had a death rate of 200 per 100,000 a year in Canada. Seven years later a similar facility opened nearby where those who couldn't afford to pay for treatment were looked after. This hospital became the first free sanitarium for the treatment of tuberculosis in the world.

But Gage still wanted a facility closer to the big city, so in 1903 he purchased, with his own funds, the 40-acre Buttonwood Farm near Weston. This farm had at one time been owned by John Dennis, a United Empire Loyalist, whose surname was perpetuated in the district around Eglinton Avenue West and Weston Road, Mount Dennis.

Initially, the hospital had facilities to treat two dozen patients in the pavilion and tent shacks on the property. Shortly after opening, the Toronto Railway Company donated 10 obsolete horse-drawn streetcars, which were fitted out for the treatment of 10 tuberculosis patients. In late 1910 the hospital suffered a severe fire, but was quickly rebuilt thanks to generous benefactors. Four years later when the Gage Institute opened on College Street, just west of Beverley Street in downtown Toronto, it then became possible to "go out to the public throughout the province and administer free chest X-rays, tuberculin tests, and clinical exams."

Over the years 'the San,' as it became affectionately known, drew in treatment capacity from 30 beds in 1904, 340 beds in 1915, and 573 in 1935 to a maximum of 600 beds in 1961. In recent years medical science has taken great strides in the prevention and cure of 'the white plague.'

In 1976, the hospital's name was changed to West Park.

Today a modern West Park specializes in rehabilitation services and special care for the chronically ill tuberculosis patient. Soon this important member of our community will embark on a $3.3 million fund-raising campaign to permit expansion of patient care and rehabilitation services, including construction of a facility for mentally alert, physically disabled young adults.

Patient rests in one of the former horse-drawn streetcars at the San.

WAR REMEMBERED IN MANY WAYS

November 23, 1980

Standing tall in the middle of University Avenue just north of Queen Street is the South African War Memorial. The work of Walter Seymour Allward (1876–1955), this monument commemorates the part played by Canadians in the vicious battles during the Boer War of 1899–1902. Sculpted on the monument are many of the conflicts in which Canadians participated: Paardeberg and the relief of Kimberley (February 1900), the relief of Mafeking (May 1900), and lesser skirmishes at Diamond Hill, Johannesburg, Harts River, Dreifontein, and Belfast.

The first Canadian contingent, which included 125 members of Toronto's 'C' Company, left Quebec on board the troop-ship *Sardinia* on October 30, 1899, arrived in South Africa, docking at Table Bay on November 29, and was ordered to the front two days

The memorial is now surrounded by modern buildings on University Avenue.

later. A second contingent left Halifax in January 1900. In total, Canada sent 160 officers and 2,932 non-commissioned officers and men to what has been called "Britain's last great imperial war." Toronto's city fathers gave to each of her officers a cash gift of $25 and a pair of field glasses; and to each enlisted man $5 and a silver matchbox. Nearly two years and eight months after the outbreak of the war, peace returned to South Africa on May 31, 1902.

Many reminders of the South African war remain in our city. Numerous street names of a fast-growing city at the turn of the century recognize battlefields and 'heroes' of the war: Ladysmith Avenue, Pretoria Avenue, Mafeking Crescent, Kimberley Avenue, and French Avenue (after Sir John); Lord Roberts Drive (after Frederick); Buller Avenue (after Sir Redvers); Metheun Avenue (after General Paul); Milner Avenue (after Sir Alfred); Kitchener Avenue (after Lord Horatio Herbert); Baden Street and Powell Avenue (after Lord Robert Stephanson), and others.

The photo below shows Allward's work just after its creation early in the first decade of this century and before Winged Victory was added. The grassy area in the foreground fronted onto Queen Street.

University Avenue ended at Queen Street, and a quarter-century and a world war later University was pushed south of Queen to connect with Front Street. Next week we'll look at University Avenue from the north end.

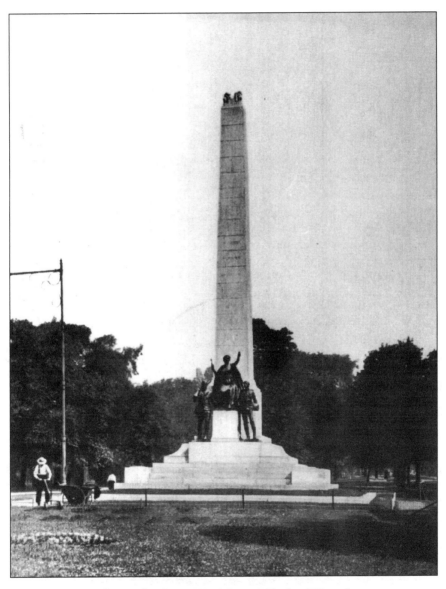

The South African War Memorial before Winged
Victory was added to the pinnacle.

ALWAYS ROOM AT THE INN

December 28, 1980

Looking for a place to spend New Year's Eve? Why not check out the list of hotels featuring special dinner and dance packages elsewhere in the paper? Years ago people had a different group of hotels to choose from. Shown here are three ads for prominent Toronto hotels at the turn of the century.

The Queen's was located on the north side of Front Street, just east of York, and started life as a terrace of row houses, later becoming Sword's Hotel, and in 1862 the Queen's. This hotel was demolished in 1926 to make way for the Royal York Hotel.

The Daly House, operated by a Mr. Hurst, was located on the southeast corner of Front and Simcoe streets, just west of the old Union Station. The station was situated at the foot of University Avenue. CN-CP Telecommunications now stands on the Daly site.

In 1909, a long-time city hotel had a name change and the Prince George was born. Built in 1858, the Prince George was originally the Rossin House, named for the builders Marcus and Samuel Rossin. In 1862, the hotel suffered a serious fire and was rebuilt the following year. The name Rossin House remained until 1909 when it became the Prince George after Queen Victoria's grandson who one year later (1910) became King George V. The Prince George was demolished in the mid-1960s to make way for the TD Centre complex.

While at the York-King streets intersection, there were also hotels that occupied the other three corners: northeast – Shakespeare, later Imperial (demolished in 1938 for the *Globe and Mail* building and now the site of another First Canadian Place tower), southwest – Iroquois, later Metropole, and northwest – Mansion

House, later the Windsor, then Palmer House, and most recently the site of the Lord Simcoe Hotel. There were numerous other hotels in the city and we'll look at some others in a future column. Do you have any favourite old hotels?

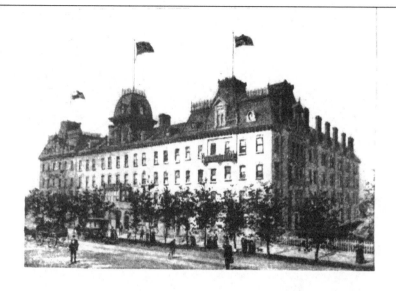

The Queen's Hotel

=TORONTO=

Is within easy reach of steamboat landing, and commands view of Lake Ontario. It is surrounded by beautiful gardens, which render it the coolest hotel in Toronto. 100 rooms and baths. Long distance phone in every room.

STRAIGHT FROM THE COW TO YOU

February 1, 1981

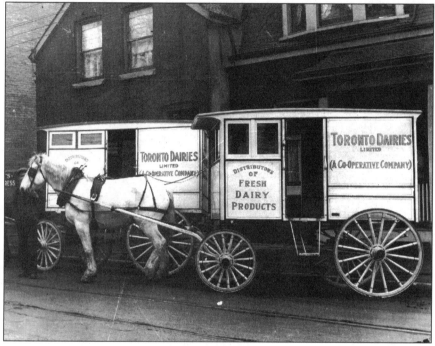

Milk carts ready for delivery.

Historians tell us that the cow made its debut in Canada in the early 1600s when one Louis Hébert established a small farm in an area now occupied by a portion of Quebec City. While the actual arrival date of Ontario's first cow is not similarly documented, it is known that some of our citizens kept a cow or two for their own use, and occasionally to supply milk to neighbours.

Before long, several enterprising citizens got into the dairy business by acquiring milk from local farmers and simply distributing the product door-to-door from large tanks on horse-drawn wagons into various bottles, tins, or whatever was supplied by the customer. In fact, one way in which the provincial government raised revenues was to place a tax of three pounds on every 'milch' cow.

While there is no record of Toronto's first milkman, it is known that several dairies had been established by 1880. One of the earliest was the Western Dairy on Queen Street, and by the turn of the century there were approximately 300 milk dealers in the city.

Keep in mind, however, a dealer merely bought milk, put the liquid in a tank, and roamed his routes dipping quantities for his customers. No treatment of the milk or bottling was involved. Milk sold for five cents a quart and two important

dairies were Caulfields, a company that became part of Borden's in the 1930s, and Adams and Sons, who introduced bottled milk to Toronto about 1905.

One of the most important of the city's early dairies was the City Dairy, which began operations on June 1, 1900, and was the brainchild of Walter Massey, the third son of Hart Massey, the man who gave this city Massey Hall (in memory of his first son Charles) and Fred Victor Mission named for his fourth. Walter had a large Jersey herd at his farm called Dentonia Park (after his wife's maiden name, Denton) on the eastern outskirts of the city and here his company prepared milk and other dairy products using the most up-to-date production practices such as pasteurization and bottle sterilization to ensure the health of his customers. City Dairy was located on Spadina Crescent just north of College Street and became part of Borden's in 1930.

The photos accompanying this article show wagons of Toronto Dairy Ltd. outside the office at 661 Gerrard Street, and a 1937 ad showing some of the other prominent local dairies.

Incidentally, in 1937 milk was 12½¢ a quart.

An early dairy products ad.

IT'S A MOOVING CNE EXPERIENCE

August 22, 1993

When you ask the old timers "what attractions do you remember from the CNE of long ago?" chances are that included in their lengthy list will be Elsie the Cow.

For years that beautiful bovine (who in later years was accompanied by her 'son,' Beauregard), drew enormous crowds in her specially decorated boudoir that was originally located just outside the Food Products building and from 1954 on in a specially constructed cottage at the north end of the majestic Dufferin Gate.

While Elsie made her first appearance at the 1941 edition of the CNE she had, in name anyway, been around for several

CNE visitors certainly flocked to see the famous bovine in a specially decorated boudoir.

years prior to that, having been created in 1936 by the advertising staff at the Borden Company as a kind of 'spokescow' for the various dairy products manufactured by the company.

Feeling that the promotion of dairy products was so low-key as to be almost non-existent, company officials decided to use cartoon cows to help sell their products. The first use of a herd of bovines was in medical journals where cows 'discussed' the virtues of the Borden merchandise thus:

> Setting: A cow and a calf are talking.
> Calf: Mama, I think I saw a germ.
> Cow: Mercy, child – run for the Borden Inspector.

It was purely by chance that the ladies of the pasture were Mrs. Blossom, Bessie, Clara and … yes … Elsie.

The campaign worked beautifully and soon doctors were asking for prints of the chummy cartoon cattle clique for their waiting room walls. Soon a radio campaign hit the airwaves in both the States and Canada. One spot featured the announcer reading the following letter:

> Dear Mama,
> I'm so excited I can hardly chew. We girls are sending our milk to Borden's now.
> Love,
> Elsie.

And while any of the names featured in the cartoon campaign could have been used, it was Elsie that was chosen, right then and there, Elsie the Cow was 'born.'

With the New York World's Fair in the offing, the Borden people had planned an exhibit depicting an operational dairy complete with 150 cows. Within days after the opening, the second most popular question posed to the staff (the first being "where are the restrooms") was "where is Elsie?"

It suddenly dawned on the Borden people that they had to have a 'flesh and blood' Elsie. Perusing the herd, all eyes fell on a good-looking seven-year-old Jersey who called the fields around Brookfield, Massachusetts, 'home.' Her registered name was "You'll Do Lobelia." Now she was simply Elsie.

She returned for the 1940 fair and this time was stabled (or whatever you do with cattle) in a bedroom setting complete with a four-poster bed.

Suddenly there were problems. Elsie had offers to appear in a Hollywood film plus she was in a motherly way. During her absence, her 'husband' Elmer took over at the exhibit (by the way, Elmer became the symbol for Borden Chemicals' Elmer Glue), but it just wasn't the same. In September, Elsie returned to the New York fair with daughter Beulah and the magic returned.

Following the closure of the extended World's Fair, Elsie went on tour. Sadly, her traveling caravan was involved in a serious traffic accident. Elsie was badly hurt and died 10 days later. Everyone thought the whole Elsie Cow concept would die as well, but it didn't.

Now Atlantic City wanted Elsie and so too did the management of the Canadian Exhibition up in Canada. Quickly, a new Elsie in the guise of "Noble Aim Standard," "Surville Wonderful Lady," or "Noblette Cymbelline" stepped into the breach and the Ex got an Elsie for its 1941 edition.

Due to the war, there were no Exhibitions (and obviously no Elsies in boudoirs) from 1942 to 1946, but when the fair returned in 1947 so too did Elsie and she remained a major attraction for another dozen or so years.

Though the Borden Company is out of the dairy business in Canada, I've been informed that Elsie still appears at functions south of the border where the company is still very much in the milk business.

MEMORIES OF THE PREVENTORIUM

March 22, 1981

Recently, reader Edith Maybee wrote to ask whether I had any information on a building she remembers visiting as a child just off Yonge Street at Sheldrake Boulevard. I spoke with Edith and with Amy Crosbie, president of the Imperial Order Daughters of the Empire Children's Centre, and what follows is the story of an old Toronto landmark known as the Preventorium.

Originally the home of Evangaline Booth, territorial commander (1896–1904) and daughter of the founder of the Salvation Army, William Booth, the large mansion faced to the west and was number 2393 Yonge Street.

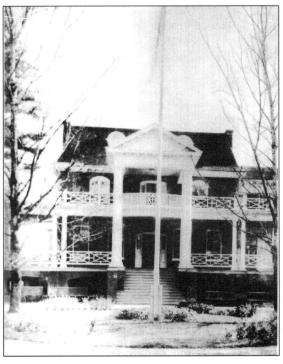

The original building.

In 1912 the IODE took over the premises, thanks to the generosity of Sir Albert Gooderham, and the building housed children of parents with consumption, or tuberculosis, as we now know the malady. About 1919, an addition to the east was added.

About the same time, the valuable Yonge Street frontage was sold off and the building became Sheldrake Boulevard. In 1941, the Preventorium became the Empire Hospital for Convalescent Children and seven years later the Sanitarium for Consumptive Children.

As the incidences of tuberculosis continued to decline, the IODE realized that an alternate field in child care had to be found. The old hospital was demolished in the late 1950s and the land was leased to a developer who recently built numerous leasehold homes on the property.

These are the facts in the life of the Booth mansion, but the story would be incomplete and rather lifeless without some reminiscences from Mrs. Maybee who remembers the Preventorium's early years:

It certainly was out in the country! It was surrounded by fields, woods and farms. I don't think even the huge, suburban street-cars had started running yet, as we came in a 'jitney,' private cars making a few pennies driving people up and down this muddy country road called Yonge Street.

It must have been spring, as I remember the daffodils; there was a slight rise of ground that had suddenly fallen away and they stretched all along the rim as tho' they had run up the hill, trying to peer over the edge to see what was down there. Oh blissful memory! In time the gardens were subdued and planted, a fit setting for the rambling old Victorian mansion.

When the horns were tooting – and the sirens blowing like crazy announcing the armistice, a little round eyed girl sat up in bed and said very solemnly, 'That's the Kaiser crying,' and Miss Baker tossed candy kisses around to celebrate!

Hope you aren't bored by these wild ramblings, but the mention of the Preventorium is like handing me a glass of clear spring water, I jump right in and bubble up like Eno's Fruit Salt! Those were the happiest days of my childhood.

Chicolata, chocolata, spearmint gum
Who put the night-nurse on the bum? The kids of the pre-ven-tor-ree-um.

(our 'little college' yell)

Note: Chiclets and a drink called Chocolata had just become popular; Chiclets stayed on, but Chocolata fell by the wayside.

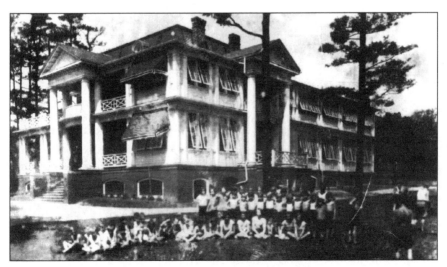

Youngsters gather on the lawn outside the new wing.

127

WHEN THE MOVIES CAME TO TOWN

April 26, 1981

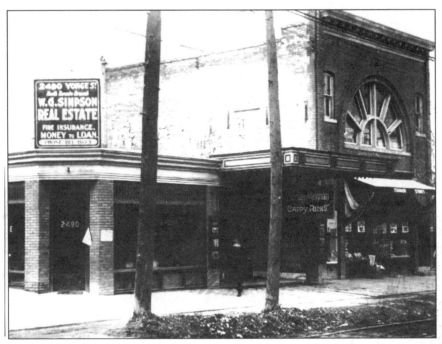

The Capitol Theatre on Yonge Street in 1921.

With the multitude of movie theatres scattered around Metro Toronto, it's interesting to look back and revisit the earliest movie house in the city. We must go back further than the Madison on Bloor at Bathurst, the Hippodrome on Bay, or the Red Mill on Yonge. We must, in fact, go back to a small store on Yonge Street opposite the present Strand Building just north of King.

It's the fall of 1896 and McGee's Musee, a small exhibit hall containing freaks and other weird attractions, has just been purchased by M.S. Robinson of Buffalo.

The newly opened Robinson's Musee installed a kinetoscope, a rudimentary form of movie projector, in the basement and for 10¢ the visitor could go to the 'movies.' Incidentally, Robinson's Musee, or theatre, opened scant minutes before Toronto's second movie house across the street turned on its cinematograph.

Back in Robinson's the first motion picture to be shown in Toronto was the *Kissing Scene* starring Mae Irwin and John Cohn. It was a 120-footer and the film fed through the projector into a laundry basket on the floor.

The projectionist was Edward Houghton who, in the following year, filmed the Corbett-Fitzsimmons fight in Carson City, Nevada, on special projectors using double-width film. Other movies shown at Robinson's were *Shooting the Chutes at Coney Island, The Black Diamond Express,* and Lois Fuller's *Serpentine Dance.*

This latter was a colour film with the snakes hand-painted green to allow the audience to see Lois's supple body more distinctly. It was a tremendous hit. It seems as if today's adult movie houses have nothing on Lois Fuller.

The photos accompanying this article show the Pantages theatre box office – matinees 30¢, evenings 55¢ – and the original Capitol theatre on Yonge Street at Castlefield. The Pantages opened in 1920 and following the Fatty Arbuckle scandal, the theatre changed its name to the Imperial, now the Imperial Six.

Under the personal guidance of Garth Drabinsky, what had most recently been known as the Imperial Six was beautifully restored to the grandeur it knew in the 1920s. The 'new' Pantages reopened September 20, 1989, with the Canadian premiere of Phantom of the Opera.

The vestibule of the Loew's Yonge Street (Elgin) and Winter Garden Theatres showing the box office, entrance doors, and stained-glass transoms in 1915.

BLOOR WAS VILLAGE BOUNDARY

November 8, 1981

B loor Street, or to give it its original appellation, the First Concession Road (as it was a full concession – 1¼ miles or 6,600 feet or 100 chains – north of Queen Street), was the south boundary of the Village, later Town, of Yorkville.

Yorkville was Toronto's first suburb and consisted of 557 acres squeezed into the area bound by Sherbourne Street on the east, to a line approximating today's CPR line on the north, Bedford Road to the west, and Bloor Street at the southerly end.

Established as a town on January 1, 1853, the municipality continued to grow steadily thanks in part to the popular Red Lion Inn situated on the east side of Yonge, just north of the concession road, as well as the town's proximity to the big city to the south.

One drawback to the community's early westward development was the existence of the York General Burial Ground that occupied six acres on the north side of Bloor Street, stretching almost to Avenue Road.

The cemetery was incorporated in 1826 and after considerable discussion between the townsfolk and the cemetery trustees, it was closed in the mid-1850s

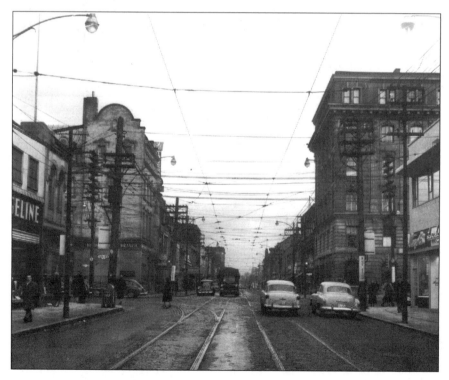

Yonge Street, looking north to Bloor, 1955.

with the bodies being reinterred at the Necropolis and Mount Pleasant Cemetery, where a 'pioneer plot' continues to be maintained.

The town boasted several prosperous industries, including two breweries: Bloor's Brewery in the ravine just north of the concession road and west of Sherbourne Street, and Severn's Brewery in the same ravine east of Yonge Street, north of Davenport Road.

The proprietor of the former, Joe Bloor, gave his surname to the present thoroughfare in the mid- to late-1850s. John Severn is remembered in Severn Street near Canadian Tire. A third important industry was the Yorkville and

The present day four corners.

Carlton Brick Works where Leonard Pears manufactured bricks used in the construction of the Asylum, St. Michael's Cathedral, and University College, among others.

In 1904, the city purchased the then inoperative Brick Works and in 1907 converted what was called 'Tannery Hollow' into a city park, assigning the name Ramsden, in tribute to George Ramsden who was active in city politics for many years and lived on Yorkville Avenue.

Several years earlier in 1883, the city had annexed the entire Town of Yorkville, making the one-time suburb St. Paul's Ward.

To learn more about Yorkville, the public library has prepared a fascinating little booklet entitled *Yorkville in Pictures 1853-1883* which is available at most city branches.

NEGLECTED PART OF HISTORY

November 1, 1981

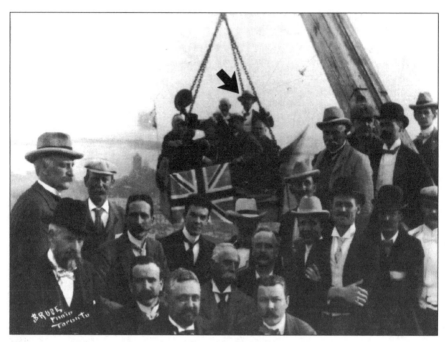

The arrow points to city politician William Hubbard at the topping-off of the clock
tower ceremonies at the new Toronto City Hall, July 14, 1898. Others in the
Union Jack–draped basket include Mayor John Shaw and his adventuresome wife.

Daniel Hill has authored a new book on a subject that is both fascinating and,
in some cases, embarrassing. *The Freedom Seekers* (The Book Society of Canada,
Ltd.) documents the trials and triumphs of the blacks in the early days of our
country.

From little Olivier LeJeune, a six-year-old slave who was brought to Canada
from Madagascar in 1628, through the war years of 1812–1814, when the blacks
distinguished themselves by fighting with Brant and Brock against the invading
Americans, to the heroic exploits of William Hall, the first Canadian sailor and the
first black to win the Victoria Cross, Dr. Hill's book covers an important yet
heretofore largely neglected component of our country's history.

Of particular interest to Torontonians is the story of William Peyton
Hubbard. Hubbard, the son of a refugee from the state of Virginia, grew up in the
1840s in an area of the young city known as 'the bush,' now the Bloor
Street–Brunswick Avenue district of Toronto. Trained as a baker at the Toronto
Model School (now the site of Ryerson Polytechnical Institute) and actually

patenting an oven named the Hubbard oven, he entered civic politics at the relatively senior age of 51. Elected alderman for Ward 4 in the 1894 campaign, Hubbard resided at 51 Bathurst Street, just south of King Street, and ran a livery stable at 20 Nelson Street.

He went on to win the next 13 annual elections, serving on the Board of Control from 1898 until 1907. For the years 1904–1907, Hubbard was vice-chairman of the board and acted as deputy mayor of the city on numerous occasions.

Two of Hubbard's chief causes were the public ownership of the city's water supply and the creation of a publicly owned enterprise that could generate, develop, and lease electricity. This latter stand was not popular with the electorate and led, indirectly, to his defeat in the 1908 civic election.

But Hubbard along with others led by Adam Beck were soon to witness the birth of the Ontario Hydro and the Toronto Hydro-Electric System, thereby fulfilling their collective dreams.

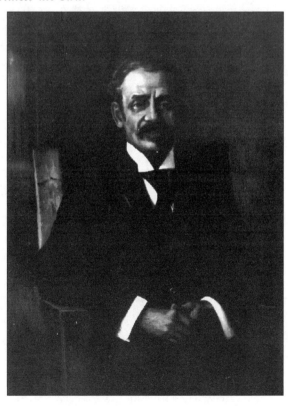

Prior to his retirement from city politics, Hubbard sat as alderman for Ward 1 in 1913 then, to be with his seriously ill wife, left politics in 1914.

Hubbard once wrote of himself, "I have always felt that I am a representative of a race hitherto despised, but if given a fair opportunity would be able to command esteem."

William Hubbard died at his home at 660 Broadview Avenue in 1935.

FROM THE PAGES OF HISTORY

April 11, 1982

The University of Toronto Press has just published another volume in the continuing series *Dictionary of Canadian Biography*. To date seven volumes of a planned total of 12 have been released.

This most recent work, volume 11, contains the biographies of 586 prominent Canadians who died between 1881 and 1890. Of these 586, many familiar Toronto and area dignitaries are included, making this work of immense importance to researchers of local historical works.

Two such personalities included in this volume are John Macdonald (1824–1890), pictured on opposite page, and John McCaul (1807–1887) above.

Reverend John McCaul (1807–1887)

Macdonald was born in Scotland and arrived in Canada with his father when the latter's military regiment was called on to quell disturbances during the 1837 turmoil.

He was educated in Toronto and received his early commercial training at several dry goods companies and in 1849 opened his own retail store.

He became more successful in the wholesaling/jobbing business and by 1860 John Macdonald and Co. was the largest dry goods house in the country.

His five-storey gothic-styled warehouse on Front Street, west of Yonge, was one of the architectural gems of the city.

One of his customers was a struggling Timothy Eaton.

In 1860, Macdonald, now referred to as the Merchant Prince, built the lovely house on the Avenue Road hill known as Oaklands which is now the home of De La Salle boys' college.

In addition to his business interests Macdonald was a devout and busy Methodist layman contributing great sums of money to his church as well as to the YMCA and Salvation Army.

In 1887, Macdonald was appointed to the Senate by Sir John A. Macdonald (no relation). On February 4, 1890, Macdonald died at Oaklands and he was buried at the Necropolis.

John McCaul was born and educated in Ireland, being admitted as a priest of the Church of Ireland in 1833.

Five years later, upon the recommendation of the Archbishop of Canterbury, McCaul accepted the position of principal at the recently established Upper Canada College in Toronto.

In 1842, McCaul was appointed vice-president and professor of classics, logic, and rhetoric of the new King's College, the forerunner of today's University College which, while chartered in 1827, didn't actually commence classes until June of 1843.

In 1848 John Strachan, principal of King's College, resigned to spend more time on his clerical duties as bishop, and McCaul became the new principal of King's College.

John MacDonald (1824–1890)

Five years later the Anglican-leaning King's College was remodelled by an Act of Provincial Parliament into the secular University of Toronto, and John McCaul was named president of University College where he remained until his retirement in 1880.

McCaul Street in downtown Toronto is named for this prominent educator.

MUSIC FILLED THE AIR

September 12, 1982

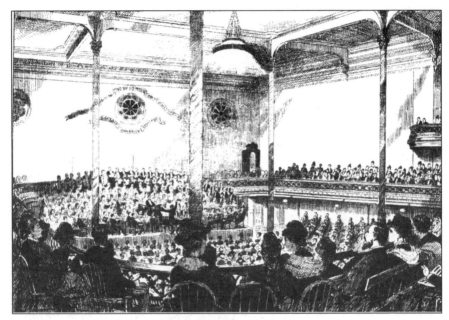

Toronto Philharmonic in concert.

Tomorrow, September 13, Toronto's new 'crystal music box,' the Roy Thomson Hall, presents its premier performance.

More than five years in the designing and building stages, the hall is the new home of the Toronto Symphony and the Mendelssohn Choir. As well it will host world-famous orchestras and solo performers.

While all eyes are on the Roy Thomson Hall, I thought it would be interesting to look back at an earlier Toronto and some of its music. The Toronto Symphony has as its predecessor an orchestra known as the Toronto Philharmonic Society (seen performing in the sketch) which was formed in the 1870s and was the city's first regular full orchestra. It performed symphonies and concertos under the direction of F.H. Torrington. These performances were held in Shaftsbury Hall at the northeast corner of Queen and James streets, or at the Horticultural Pavilion that was situated in Allan Gardens and was to be destroyed by fire in 1902. The present Palm House was erected on the site of the Pavilion (shown on opposite page) in 1909.

Unfortunately, the Toronto Philharmonic Society lasted only a few years, and it wasn't until 1906 that the city got another permanent orchestra, known as the Toronto Conservatory Symphony Orchestra under the direction of Concert Mistress Bertha Adamson. Two years later the orchestra's name was changed to the

Toronto Symphony Orchestra (TSO). Over the next 11 years the TSO gave regular concerts at Massey Hall, with guest artists such as Kreisler, Elgar, Elman, and Rachmaninoff.

With the coming of the war years it became increasingly more difficult to keep the orchestra together, and in 1918 the TSO was disbanded.

Five years passed before there was enough interest in resurrecting a permanent orchestra, and on April 23, 1923, the New Symphony Orchestra under Luigi von Kunits played its first concert. Made up primarily of movie-house musicians (sound movies were still four years away), the symphony concerts had to be held at 5:00 pm to permit the orchestra members (who, incidentally, received $3.95 per concert) to get to their 'real' jobs at Shea's or the Uptown or one of Toronto's many other movie houses.

In 1927 there was another name change, this time to the Toronto Symphony Orchestra. From that time to the present (with but a slight name change affected in 1967 when 'Orchestra' was dropped from the title), the Toronto Symphony, under conductors Sir Ernest MacMillan (1931–1956), Walter Susskind (1956–1965), Seiji Ozawa (1965–1969), Karel Ancerl (1969–1973), Victor Feldbrill (1973–1975), and the present conductor, Andrew Davis, has entertained hundreds of thousands of music lovers in Toronto and all over the world.

The Toronto Symphony embarks on a new chapter of its proud history tomorrow when Massey Hall is left behind and the new Roy Thomson Hall becomes home to our Symphony.

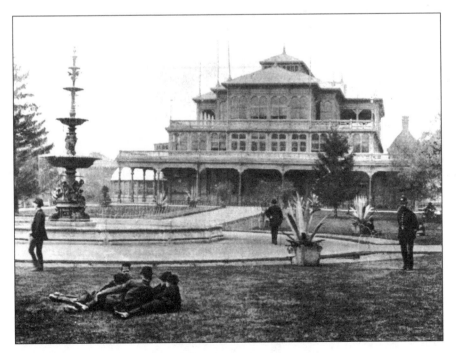

Palm House erected in 1909.

RAILS GO ELECTRIC

August 15, 1982

Today marks a special anniversary in our city, as it was 90 years ago exactly that Toronto's first electric streetcar route was inaugurated.

Up until August 15, 1892, Torontonians had been served by a fleet of horse-drawn vehicles running on rails laid on the various major thoroughfares.

The first horsecar began in 1861 from the St. Lawrence Hall along King Street and north on Yonge to the Yorkville Town Hall, just north of Bloor. The fare was five cents and the cars operated 16 hours a day in summer, 14 in winter, and at speeds not to exceed six miles per hour. This service was owned by the Toronto Street Railway whose charter expired in 1891, and after a brief attempt by the city to carry on operations a new company, the Toronto Railway Company (TRC), headed by Sir William Mackenzie of Canadian Northern Railway and Benvenuto mansion fame, took over on September 1, 1891. Included in the contract between the city and the company was the clause that "electric streetcars be introduced within one year and the system totally electrified within three years."

Electric streetcars had been operating successfully in several Canadian and American cities since 1886 and, in fact, the one-mile-long line down at the Exhibition Grounds had been a commercial success since 1884 after a rather shaky start the year previous.

For several weeks prior to the 'official' conversion of the Church route to electricity, a couple of new electric cars and their operators undergoing training could be seen on the route.

During this period the *Evening Telegram* wrote several editorials condemning the "wicked cars," insisting that terrible accidents would be commonplace following their introduction.

"Toronto should have safe, sane cable cars instead," screamed the paper. Nevertheless, on August 15, 1892, just two weeks prior to the end of their first year in business, the TRC opened their first electric line with all due pomp and ceremony. Over the next two years all the remaining lines were similarly converted with the last horse-drawn vehicles being withdrawn from the McCaul Street portion of the Dovercourt route on August 13, 1894.

In the rare photo accompanying this article we are looking east on King Street at the turn of the century, just a few years after electric streetcars had been introduced. The very first such car in regular service was number 270 and it had been built by the company in their building at the northwest corner of Front and Frederick streets. The car was 18-feet long and seated 24 riders. In 1905, this car and number 284 were joined together and with some modification became Twin Body Car 270 which burned in the King Street car barn fire in March 1912.

In the photo, electric car 446 is seen in the Belt Line service pulling a former horsecar converted to a trailer.

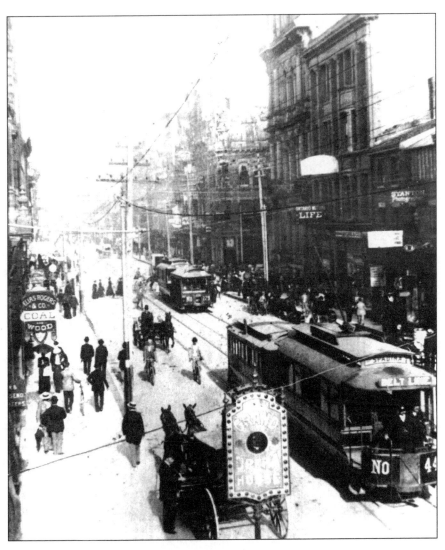

Old Number 446 plies Toronto streets.

HOTEL OF MANY CHANGES

December 5, 1982

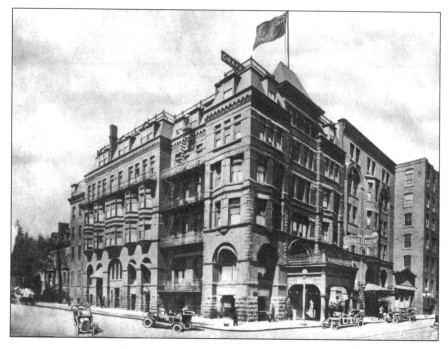

The old Grand Union Hotel at Front and Simcoe streets.

I wonder how many readers remember this old downtown hotel?

Over the years it was known by several names and was originally built to serve the needs of the railway traveller. This hotel stands at the northeast corner of Front and Simcoe streets. I remember it in its latter days as the Hotel Barclay, complete with belly dancers in a room whose name I now forget. As I recall, at the time this was a unique feature in the city.

While the structure shown dates to the 1890s, the site was occupied by a hostelry from a much earlier time. In fact, it was just a year after incorporation that the first hotel and tavern appeared, known as the City of Toronto Tavern and later as the St. James' Hotel. According to the 1893 city directory, a new building was under construction and opened soon thereafter as the Grand Union. In 1915 the name was changed to the Carls-Rite Hotel after Edward Carol and George Wright, co-owners. Wright also owned the Walker House just across Front Street.

A number of years later the hotel underwent another name change and became the Hotel Barclay.

Torn down a few years ago, the hotel site is now occupied by a parking lot.

The Barclay Hotel has since been replaced by a parking lot.

A FOND LOOK TO THE EAST

April 3, 1983

The old Ford plant on Danforth Road is one East End memory.

E very once in a while I receive a collection of memories from readers who wish to share them with others. Such is the case with today's article, signed simply "an East-Ender named Jim." His memories of East Toronto provide both entertaining and interesting reading.

Memories of East Toronto

Fifty years or so ago Toronto was simply 'Hog Town' to many people, the 'City of Churches,' and divided into the Forest Hills, the Rosedales, Cabbagetowns, Parkdales, and Junctions ... but to me, it was the 'East End!' From a modest beginning has grown a fabulous, bustling metropolis of more than two million souls of mixed races, religions, nationalities, and cultures. Most feel we are the better for it.

Summer was always a welcome time for a favorite pastime of mine as a boy ... 'train watching' from a vantage point near the then Victoria Park Avenue level crossing ... now an underpass. And what a thrill it was when the crossing guard emerged from

his tiny shanty to blow a whistle and hold aloft a sign which read STOP. That meant, of course, that a train was coming, starting the magic tingle and beating the heart a little faster.

Just north of the crossing, at the corner of Victoria Park and Danforth (now part of the Shoppers World parking area) was the York Market, with rows of tables and stalls, where farm folk from near and far displayed their produce and other wares for sale. The market was great for a Saturday visit when on the way to the 'show,' a small theatre called, I believe, the Avalon ... on the south side of Danforth, near Luttrel, where the Bloor and Carlton street-cars looped. Admission price for the show was a nickel and brought thrilling serials which starred such cowboys as Hoot Gibson, Tom Mix, and Ken Maynard.

Supermarkets and plazas were unheard of and the 'corner store' was the shopper's dependable supplier. Everyone enjoyed the personal door-to-door service by tradesmen. The milkman was seldom seen for many of the deliveries were made through the night but it was always an occasion when the 'baker' came to the door with his wicker basket of bread, cakes, and buns.

No story about Toronto's East End would be complete without a mention of 'the pit.' It was a former sand and gravel operation, perhaps a quarter of a mile long, 300 hundred yards wide and maybe 75 feet below street level. It lay between the ice house of the CN's Danforth yard and the backyards of a row of houses on the north side of Gerrard East in the Pickering Street, Lawler Avenue, and Scarborough Road area, but stretched almost to Victoria Park. In summer, there were gently sloping banks of white sand on which neighborhood people, young and old alike, sunned themselves by the hour. The pit contained a pond on which the kids had rafts to pole about.

The East End I knew and loved is still there but somehow, something has been forever lost. The great and once bustling Danforth yard is mainly silent, except for 'through' trains. The giant ice house, where refrigerator cars were 'iced up' was destroyed in a spectacular fire. The long Ford plant is now part of Shoppers World and the many little theatres have been passed out of existence by television.

No attempt to belittle progress and change is intended, for it is all part of the growth of a great city. But ... the pit, which was such a joy, was filled in and built upon years ago.

However, my 'East End' is still there, but for me and no doubt many others, the memories of what it once was, remain.

PARK WAS A MILESTONE

June 19, 1983

Tootsie gave kiddie rides in A.W. Miles Park. ('A.W.' is second from left.)

A.W. Miles, the well-known Toronto funeral director, lived for many years on a two-acre farm on the shore of Lake Ontario at Mimico. Miles Road, named in his memory, runs from Lake Shore Boulevard just east of Royal York Road to the lake, and today marks the area where the first Miles Park was developed and flourished for 20 years, from 1913 to 1933.

In the early years, church congregations were transported by horse-drawn wagons to the farm which housed an elephant, a camel, two llamas, several monkeys, and about three dozen donkeys and donkey carts. The animals and cart rides were always a hit with the children and there was nothing like a swim in the lake

after the games and races. Even the animals enjoyed the water. One day an elephant wandered in and refused to budge from the water for an entire day!

As Mimico developed into a residential community, it became apparent that the original park was not appropriately situated. Miles, remembering his childhood days when he could not afford entrance to a zoo, decided to build his own super zoo! It would be free to all and would be primarily used by church and charitable groups.

In 1936, A.W. Miles Park, the 200-acre creation of Miles, was opened one mile west of Erindale, north of the QEW. All of the Mimico animals were moved to the new location and Miles added more, including several dozen deer, ostriches, peacocks, and the famous baby elephant, 'Tootsie,' who was only six months old when she arrived with her Burmese trainer via New York.

Miles's son, A.W. 'Bill' Miles, was trained to handle Tootsie by the trainer and the animal became widely acclaimed as a circus elephant. Cub bears were brought to the park each spring and returned to their natural environment each fall.

Art 'Baldy' Stewart was the farm manager and he was responsible for keeping the confectioner booth stocked with complimentary ice cream. There was a picnic hall, where up to 150 church picnickers could enjoy their lunches indoors. Also, there was a specially built and heated building which housed the zoo animals in winter as well as the supervising staff who cared for the animals.

Complimentary buses, full of enthusiastic church members, could be seen at the park on Wednesday afternoons and Saturdays. Sundays were also the busiest days when the park was open to the public and it was not unusual to see 1,000 or more people present at the peak of the season.

Faulty heating equipment was blamed for the tragic fire which destroyed the A.W. Miles Park facilities and most of the animals on the coldest night of January in 1944.

A.W. Miles was heartbroken over the loss. The war was in progress and it was almost impossible to replace the exotic animals. The donkeys and monkeys which survived were given away and the park was never reopened as the happy place which many will remember. Finally, in 1956, the land was sold to a developer and the park closed forever.

On July 16, 1982, the Yonge and St. Clair Chapel of A.W. Miles, which had originally opened in 1901 on College Street near Spadina Avenue, closed and the quaint old building was demolished. But the name 'Miles' still survives as the A.W. Miles Chapel of the Humphrey Funeral Home on Bayview Avenue. Old 'A.W.'s' philanthropic nature also lives on, this time in conjunction with the Metropolitan Toronto Zoo in Scarborough.

DISASTER ON THE RAILS

July 3, 1983

Streetcar 685 shown after the accident. Most of the victims who died or were badly injured were thrown out of the open car.

This coming Thursday marks the 68th anniversary of the worst electric streetcar accident in the country's history.

The tragedy, which occurred at Queenston, involved members of the congregations of two prominent Toronto churches who had chosen that Wednesday, July 7, 1915, to hold their annual picnics near the picturesque Niagara River.

Members of Woodgreen Methodist Church on Queen Street East, and St. John's Presbyterian on Broadview Avenue, arrived at Queenston about mid-morning on the steamer, *Chippewa*, and for most of the day enjoyed the friendship and food typical of church picnics.

Early in the evening it began to rain and many of the picnickers who had been visiting the Brock Monument on the Heights raced for the waiting streetcars of the International Railway Company.

This company originated in 1891 as the Queenston-Chippewa Railway.

In 1902, the line was acquired by the Buffalo, New York–based Buffalo Railway Company (BRC). The BRC soon became the International Railway Company (IRC) and operated the highly popular Great Gorge Route that ran on either side of the Niagara Gorge right at water level. It was car 685 of the IRC that awaited the rush of church picnickers that fateful evening so many years ago.

It didn't take long for the 85-seat open car to fill, and soon picnickers were hanging on to every available space. The car slowly moved off carrying an estimated 170 passengers, and as it began its descent towards the steamer dock in the town, the wheels on the tiny vehicle began to lose traction on the rain-greased rails.

Slowly at first, the motorman began to apply the brakes at intervals, then, the brake rod snapped. The weight was too much. The car picked up speed, the trees flashed by.

The car was travelling at 75 mph as it lurched, suddenly, into the curve at the bottom of the hill. It heaved, straightened, then toppled over, sliding into a grove of trees adjacent to the tracks.

It was quiet for a few seconds, then, murmurs of the injured could be heard. Just a few at first, then the air was filled with the moans and cries of the hurt and near dead.

Shortly after, the second car in the parade arrived on the scene and mercifully was able to stop.

Soon people were everywhere tending to those thrown clear, while others lifted the shattered car off those less fortunate.

Troops on manoeuvres at the Niagara-on-the-Lake Military Camp arrived to administer aid. The news soon reached Toronto.

Fifteen of her citizens had been killed (some from their injuries while on board steamers returning home from Queenston) and more than 130 had been injured. An inquest was held, and both the motorman and general manager of the streetcar company were arrested but soon released. Many changes to the right of way and tracks were ordered, and improvements to the safety features on the streetcars were also effected.

The line continued to be a popular mode of transportation, between steamer docks and the Falls, for many years, but by the 1930s this factor had reversed and the line ceased operating in September of 1932 to be replaced by buses.

STREETCAR NAMED DISASTER

August 7, 1983

Several weeks ago I related the story of Canada's worst electric railway accident. It occurred on July 7, 1915, at Queenston, Ontario.

Since that column appeared, a couple of related photos have popped up. Briefly, late in the afternoon of July 7, 1915, car 685 of the International Railway Company, loaded with almost 180 passengers from two Toronto churches, roared, out of control, down the Queenston Heights hill, tipped over near the base of that hill in the Village of Queenston, and slammed into a tree.

Fifteen passenger died, either immediately or while on board ship, returning to Toronto. More than 100 were injured, some seriously. The two new photos that accompany this article give some idea of the conditions just before and after the disaster occurred. The first view (bottom) (from the files of Mr. C. Nash of Niagara Falls) shows car 684 (the car involved in the accident was 685) descending from the Brock's Monument.

In the background is the Niagara River and the Village of Queenston, where the accident occurred. The car in the photo curved back towards the village and Toronto steamer docks just to the left of this view, and it was here that the motor-man lost control of his vehicle.

It then raced down the embankment to the curve shown in the photo (top). This picture (from Chris Norman at the Ontario Hydro Archives) was taken some years after the accident and shows a streetcar climbing the hill headed for the monument.

The sharpness of one of the curves is evident, although this picture was taken after alterations to the right of way had been completed following the disaster.

OUR LANCASTER LANDMARK

July 24, 1983

Lancaster *FM-104* on display near Ontario Place on Toronto's waterfront gives you some idea just how big this plane was.

L ast week I wrote about a 60-year-old 'landmark' of our city that continues not only to operate, but to earn its keep. I'm referring, of course, to the Peter Witt streetcar 2894 that still sees service as a unique sightseeing vehicle.

Another landmark in town is the Lancaster bomber situated just east of Ontario Place on the south side of Lake Shore Boulevard. Now inexplicably designated *CF-GAR*, the aircraft was originally numbered *FM-104*.

The Lancaster was developed by A.V. Roe at Manchester, England, from the twin-engine Avro Manchester, the contract for which had just been cancelled by the British government. A.V. Roe developed the larger Lancaster "just in case," and a good thing, too, because it soon became the best night bomber of the somewhat unexpected, but not unforeseen, war with Germany.

In December of 1941, plans were under way to have the 'Lanc' built by the National Steel Car Company (which became Victory Aircraft in 1942 and A.V. Roe Canada in 1945) at their Malton plant northwest of Toronto.

The first Canadian-built Lancaster, dubbed the *Ruhr Express*, flew on August 1, 1943, following a brief ceremony of wishing the crew well as they left the airport to fly directly into battle with the Axis. Unfortunately, as some additional electrical work had to be done on the craft, and since they had left to go into battle, a special work crew had to be sent to Montreal where the *Ruhr Express* was finally completed.

During the period August 1943 to September 1945, 422 Lancasters were built for the RCAF. They were ferried to England and saw service in the Battle of Berlin, duty as mine-laying aircraft, and in support operations for Allied troops before and after D-Day.

Canadian-built Lancasters saw service with 419, 420, 425, and 428 Squadrons of Number 6 Bomber Group. After the war the surviving Lancaster Xs, as the Canadian-built aircraft were known, were returned to Canada and put into storage.

In 1946 some Lancasters were modified for peacetime use, including *FM-104* which was assigned to Maritime Air Command.

On April 9, 1964, *FM-104* was retired from service at a special ceremony at Downsview. The aircraft was subsequently refurbished by the Royal Canadian Air Cadets of Metropolitan Toronto and put on display in the park south of Lake Shore Boulevard where it can be seen today.

'Passing out' ceremony at Base Downsview, April 1964.

DOROTHY'S BACK

September 10, 1989

When I was a kid growing up in a very different Toronto, my theatre (we all had our 'own' theatres in those days) was the Alhambra on the north side of Bloor Street, just west of Bathurst.

We lived around the corner at 758 Bathurst Street (phone number Melrose 2154 – remember those prefixes?). While the Midtown Theatre, just east of the Bathurst Street corner, was just as close, there was something special about the Alhambra. Perhaps it was the manager, a tall, jovial fellow by the name of Pat Tobin, and his mother, the theatre matron, always crisply attired in her white outfit. Whatever happened to theatre matrons anyway?

You know, I remember helping them clean up on Sunday mornings (shows didn't operate on Sundays back then) and eating all the cold popcorn I wanted out of the machine in behind the candy stand. Of course, over the years we

Ad for the *Wizard of Oz* at Loew's Theatre, in the *Telegram*, September 13, 1939.

lived at Bathurst and Bloor, I must have seen a zillion movies at the Alhambra, but the one I'll always remember was the *Wizard of Oz*. I sat through it a dozen times until my mother finally came and dragged me out of the theatre.

The year was 1949 and the newly released book the *Wizard of Oz – The Official 50th Anniversary Pictorial History* (Warner Books), tells me that what I saw was actually the reissue of the film. The original had its public premiere in New York City at

the Capitol Theatre on August 17, 1939, two years before I was even born. The film made its Toronto debut at the old Loew's Theatre on Yonge Street, just across from Eaton's main store on September 14 of that same year (50 years ago this coming Thursday). On that same day, the *Wizard of Oz* opened across the entire country, and in the province of Quebec it was the first time in eight years that minors under 18 could enter a movie house without being accompanied by an adult.

The review in the late lamented *Telegram* newspaper wasn't overly enthusiastic about the film:

> If Walt Disney had made the film it would be an enchanting fantasy. Produced without his magic touch, it is an entertaining piece but with no fantasy at all. Children will like the *Wizard of Oz*, but will not be carried away by it.

As it turned out, the film ran less than three weeks before being bumped by a pair of features, *Lady of the Tropics* and *On Borrowed Time*. Actually, the *Wizard of Oz* set numerous attendance records, but because the majority of the audience were children, the net receipts in its first year of distribution were not enough to cover the cost of the $3 million production.

In addition, the year 1939 was an exciting one for movies and soon other major releases (*Gone With the Wind*, *Goodbye Mr. Chips*, *Stagecoach*, and *Ninotchka*) bumped the Wizard of Oz out of most theatres. And the war raging in Europe stifled the overseas distribution network even further.

Exactly 50 years, three months, and two days after it premiered in Toronto in 1939, the *Wizard of Oz* will return to the same theatre in which thousands of Torontonians first saw Dorothy and her three pals. The old Loew's Theatre is now the beautifully restored Elgin and it's not the film that's being resurrected yet again, but rather it will be the new and highly acclaimed Royal Shakespeare Company's stage presentation, complete with all those great songs sung by Dorothy and the gang.

Oh yes, the Wizard, Toto, Tin Man, Cowardly Lion, Scarecrow, and even Miss Gultch (boo! hiss!) will be there too.

Information on tickets for an ultra-special, opening night, fundraising gala (including the return of vaudeville to the Winter Garden Theatre upstairs) on December 15 at the new 'old' Elgin Theatre can be obtained by calling the Ontario Heritage Foundation.

HEROES OF *NORONIC*

September 17, 1989

Twenty-seven-year-old Don Williamson had completed his shift at the Goodyear Plant in New Toronto and, after agreeing to drive a friend downtown, he decided to make his way home on Dufferin Street.

Although it was late, past one in the morning in fact, the young man who had worked on the lake boats, could always find a few minutes to survey the ships tied up along Queen's Quay.

In those days, the Port of Toronto was a very different place with all sorts of passenger and freight boats lining the headwalls from one end of the bay to the other, with others moored in the harbour waiting for a place to tie up along the quayside. In fact, hadn't he read somewhere that the elegant passenger ship, *Noronic*, had arrived in Toronto about dinner time on Friday for a brief overnight stop before heading down the lake for Prescott?

"Bet she'd be a sight to see, even this late at night."

As Williamson turned onto Queen's Quay, he suddenly heard the sound of a ship's whistle blasting the dreaded fire signal — 10 short blasts followed by one, two, or three additional blasts, depending on where, forward, amidships, or aft, the fire was raging. Approaching the foot of Yonge Street, he could distinctly see flames dancing from the stern of a large passenger vessel moored from the stern at Canada Steamship Lines Pier 9.

Noronic was on fire!

Quickly, pulling his car over to the side of the road, Williamson rushed over to the iron fence surrounding the pier, scrambled over it, removed his heavy jacket and jumped onto a large painter's raft floating in the slip.

Calling encouragement to those huddled on the deck of the ship, a ship that was now a blazing inferno, Williamson was soon busy plucking those who had the nerve to jump over the steep railings into the black water below to get into his raft.

At almost the same moment that Williamson was arriving on the scene, Constables Ron Anderson and Warren Shaddock in the Toronto Police Department's accident car number 3 were turning onto Lake Shore Boulevard (in those days called Fleet Street) from Cherry Street. The radio in their car suddenly came on as the dispatcher advised patrol car number 9, with Acting Detective Cole and Constable Soplet aboard, that a box alarm had been rung near the foot of Bay and Queen's Quay.

As Constables Shaddock and Anderson were near the vicinity of the fire call, they decided they too would have a quick look. But as they turned onto Queen's Quay the sky turned fire red as the ship in Pier 9 erupted into uncontrollable flames.

As Shaddock parked the cruiser, Anderson raced over to the pier, removed his uniform, and jumped onto a raft where someone else was busily pulling people, alive and dying, from the cold waters of Toronto Bay.

Through it all, the two men on the raft, strangers to each other but with a common purpose, continued to work frantically to get people to jump from the boat. The noise made it impossible to communicate with each other even though they worked frantically, just feet apart. Williamson and Anderson stayed on the raft throughout the small hours of that Saturday morning. As dawn broke, it was obvious they had done all they could. Eventually Anderson left the raft. Returning to the Strachan Avenue police garage, the constable washed and went to bed, not fully realizing the extent of the disaster.

Soon after Anderson left, young Williamson, too, left the pair's makeshift, rescue craft and headed for home.

For more than five hours, the two rescuers had been unable to say a word to each other. Another 40 years would pass before they would.

As days passed, the extent of the terrible tragedy unfolded. Of the 524 passengers and crew of 171 on board the S.S. *Noronic*, a total of 119 (all passengers and all American tourists) had died in the early hours of Saturday, September 17, 1949, *exactly 40 years ago today*, in what remains as this city's worst-ever disaster.

Several weeks ago, as I was seeking a new twist to the writing of an event that has been rehashed in the papers a hundred times, out of the blue I received a call from Don Williamson, wondering if I could find out what happened to the fellow who was on the raft that fateful morning 40 years ago. He told me he had found out later that the stranger on the raft was a policeman by the name of Ron Anderson. I knew Ron Anderson. Here was my story!

Last week I had the two fellows meet me at the Island Ferry Docks. It was here, right where thousands of happy vacationers now wait for the Island-bound ferries, exactly 40 years ago, the lives of these two men first crossed. This time it was a much happier meeting.

To commemorate the 40th anniversary of Toronto's worst disaster, at 11:00 am, Mayor Art Eggleton, accompanied by Ron Anderson and Don Williamson, will lay wreaths at the memorial in Mount Pleasant Cemetery, where five unidentified victims of the *Noronic* disaster were interred.

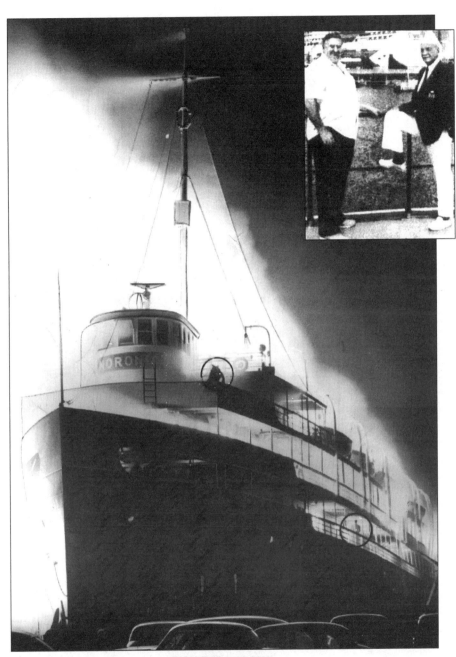

TO THE RESCUE

Noronic is enveloped in flames as passengers (circled and gathered at the bow) wait to be rescued, September 17, 1949. (Inset) Don Williamson (left) and Ron Anderson meet for the first time in 40 years on board the Toronto Island ferry, *Trillium.* The site of the *Noronic* tragedy is in the background.

A WATERFRONT LANDMARK

October 2, 1983

Terminal Warehouse as it looked 53 years ago.

Taken from identical vantage points 53 years apart, these photos show the remarkable changes in one of our city's waterfront landmarks.

Constructed in just 10 months, the Terminal Warehouse Building on Queen's Quay West was the first poured-concrete structure in Canada.

When opened in February 1927, the $3 million structure provided one million square feet of storage space under one roof, making it one of the largest warehouses on the continent. It was built as a direct result of other Great Lakes ports, with larger storage facilities than Toronto had, taking business away from the Port of Toronto. Built by the Toronto Terminal Warehouse Co. Ltd., the structure, which incidentally is built on landfill and is, out of necessity, supported on 10,000 wooden piles driven to bedrock, has had a number of owners over the years.

These companies have been headed by several prominent Torontonians: W.D. Dinnick (developer of Lawrence Park), W.H. Hearst (premier of Ontario, 1914–19), and J.S. Willison (editor of the *Globe*, and, later, the *Toronto Daily News*).

In the 1960s, container shipping resulted in the Terminal Warehouse falling on hard times as most of the warehousing was transferred to newer facilities at the east end of the harbour.

Then in 1972, the federal government announced the creation of Harbourfront with the redevelopment of the formerly commercial lands and structures on the 92-acre site south of the Gardiner Expressway between York and Bathurst streets. Olympia & York was selected to recycle the old Terminal Warehouse.

In June of 1983, after $60 million had been spent on the massive project, the structure was converted from warehousing to a complex that features 100,000 square feet of shops and restaurants, six floors of offices, and a new four-storey structure atop the 1927 building, where some of the most beautiful condominiums in the country are located.

I recently visited the old landmark and all I can say is "Thanks, Olympia & York."

Today, the old warehouse is a centre of activity at Harbourfront.

THE MAKING OF MALTON

November 6, 1983

Malton Airport just after the facility opened in 1938.

Before the decision to build an airport northwest of Toronto near the Village of Malton, the city was served by several local, small airstrips – Barker Field, Toronto Flying Club, Canadian Airways, de Havilland, de Lesseps, and an air harbour at the foot of Scott Street.

With the creation of Trans Canada Air Lines in 1937, it became obvious that a modern new facility was urgently needed. Together, the federal government and City of Toronto searched out possible sites for this new major airport.

For a while it looked like Hanlan's Point, where an amusement park had formerly existed, would be the choice, but after further study a site northwest of Toronto was selected.

Soon nine farms covering 2,600 acres had been purchased and shortly thereafter work began on the city's new airport. When the first flight landed in August of 1938, all operations, including passenger, freight, and weather were carried out in a farmhouse located just off the Sixth Line, now Airport Road.

A rudimentary control tower was built on the roof and was reached by a ladder up the side of the former Chapman residence. The following year, the Toronto

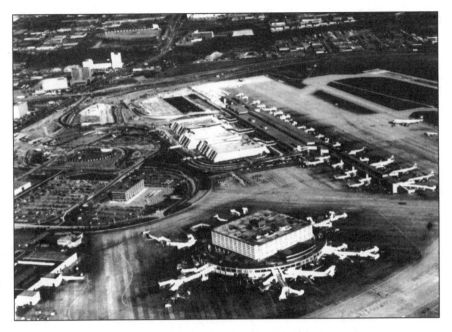

Toronto International today showing Terminals 1 and 2.

Harbour Commissioners, owners of the airport, built a wooden terminal building which was identical to the one that still stands at the Island Airport.

In 1949, the increasing number of airline flights necessitated larger passenger and operations facilities and a one-storey brick terminal was built.

This building was in use until the present Terminal 1 'Aeroquay' structure was opened in 1964 by the then prime minister, Lester Pearson. Again, increasing traffic dictated added handling capacity and a three-stage expansion began in 1969 and was completed in 1977.

Today, Toronto International (renamed in 1960) covers more than 4,300 acres and serves in excess of 14 million passengers annually.

Lester B. Pearson International Airport (renamed in 1983 to honour Canada's prime minister from 1963 to 1968) continues to undergo expansion. In January 1991, the new $520 million Trillium Terminal 3 was officially opened. Last year, 1992, more than 20 million passengers passed through Pearson's three terminals.

CHAMPS FROM PAST

May 30, 1993

One of the difficulties I occasionally experience writing a weekly column ahead of time (to meet certain newspaper deadlines) is knowing whether a contemporary subject is still relevant when the column runs.

A case in point is this week's 61st anniversary of the Stanley Cup victory. As I put pen to paper (actually finger to keyboard with automatic data storage in the CPU for subsequent download to printer) our guys are still very much in the race.

Now it's a week later and ...

• • •

Before the experts criticize my choice of the 1931–32 final as Toronto's first-ever Stanley Cup win, let me confirm that the word Toronto actually appears on the trophy on three earlier occasions: 1913–14, 1917–18, and 1921–22.

However, those victories were achieved by teams with names other than Maple Leafs, specifically Arenas and St. Pats. Historically, the first 1931–32 event was the first time the Toronto Maple Leaf team was victorious.

But to tell the whole story we have to go back a few years to the season of 1926–27 when the four owners of the city's NHL franchise, a team then known as the Toronto St. Pats, put the organization up for sale. The team had not been doing all that well and with all kinds of wealthy American investors seeking lucrative NHL franchises, this seemed to be the perfect time to sell.

In short order, an offer of $200,000 was received from interests in Philadelphia, but before any action could be taken, the owners were approached by the recently fired coach of the New York Ranger hockey team. Still smarting from his shabby treatment by the New York organization, the young man offered the quartette of Toronto entrepreneurs a mere $160,000 – plus $40,000 worth of advice.

If the owners sold out to American interests they'd certainly be branded as anti-Canadian and that would undoubtedly be damaging to their other business endeavours. It was sage advice. Torontonians took great pride in their country and didn't like anyone tampering with its traditions.

The owners took the brash young man's counsel to heart and sold him the franchise. Connie Smythe quickly renamed his team the Toronto Maple Leafs and emblazoned their jerseys with a maple leaf demonstrating to one and all his own pride in Canada.

And all the while Smythe kept in the back of his mind that someday he would get his revenge on the Rangers.

Over the next few years, Smythe's team didn't do much. In fact, it wasn't until the season of 1930–31 that they showed any sign of future greatness. That season they came third in the 10-team league consisting of an equal number of Canadian- and American-based teams.

King and pals … World champion team, the Toronto Maple Leafs, on a visit to a pipe factory in New Jersey in April 1933. Front row, left to right: Rube Bannister, Ken Doraty, King Clancy, Joe Primeau. Second row: Bill Thoms, Conn Smythe, Harold Cotton, Red Horner, Dr. N. Rush, Dick Irvin, Charlie Sands, Bob Gracie, Alex Levinsky. Third row: Hap Day, Lorne Chabot, Harvey Jackson, Andy Blair, Charlie Conacher, Fred Morrow.

Moving out of the cramped Arena Gardens on Mutual Street into Smythe's new ice palace on Carlton Street in time for the start of the 1931–32 season, the team began to slip again but at the end of the 48-game stint, once again they ranked second in the Canadian Division and third overall.

That meant that Montreal Canadiens would play the Rangers, and the Leafs would get to go up against the Blackhawks from Chicago.

New York took the Montreal team in a best of five series, three games to one, while in a two-game, total-goal series, Toronto easily handled Chicago six to two.

Now Smythe could seek his revenge. Bring on those Rangers!

Once again it would take three wins to earn Lord Stanley's trophy. The blue shirts won the first two games handily. One game to go.

Saturday night, April 9, 1932. In front of 14,366 fans, up until then the largest crowd in Canadian history to ever witness a hockey game (some of whom had even paid the ubiquitous scalpers as much as five dollars a ticket), Smythe's Maple Leafs clinched their first-ever Stanley Cup, defeating the Rangers six to four.

Connie had his revenge.

COP AND THE KID

January 3, 1993

Readers occasionally ask whether or not I ever run short of story ideas for this column.

Fortunately, with readers often sending me their own special memories of an earlier Toronto plus the fact that our community has been around for almost 200 years (it will be exactly two centuries next summer), the possibility of running out of stories is highly unlikely.

Another source of story ideas often comes from incidental details that form part of each week's "The Way We Were" feature. Take December 19th's column, for instance, in which I used a photo supplied by Jack Webster, honorary curator of the new Metro Toronto Police Museum at the force's headquarters building, 40 College Street.

The picture, taken by the talented *Evening Telegram* newspaper photographer, Nelson Quarrington, showed a young 'war guest' being greeted at Toronto's Union Station by Police Constable Harry Wharton one morning in the summer of 1940.

The caption under the photo identified the youngster as two-year-old Simon Christopher Dew who had been evacuated from war-ravaged London by his parents to the safety of his grandparent's Toronto residence. The policeman's 'London bobby look' did much to allay the youngster's fears as he stepped out confident and smiling to face a strange new world.

Five years passed, and in July of 1945, with war rapidly coming to an end in Europe, the young Simon left Toronto to rejoin his parents in England. Minutes before his train left Union Station the same Constable Warton showed up to wish the now seven-year-old boy a safe trip, and once again photographer Quarrington was on hand.

Toronto businessman Bradley Streit, who had used the 1940 photo as the subject of his Christmas card that year, obtained a copy of the 1945 photo, had the pair combined in a montage effect and reproduced it as the theme of his 1945 Christmas card.

When the newspaper ran a news item about Mr. Streit's unique 'before and after' Christmas card in its December 27, 1945 edition, an amazing story concerning that original 1940 photo came to light.

The Streits had sent a copy of their 1940 photograph to Great Britain's Prime Minister Winston Churchill who, in the midst of his country's fight for its very life, took the time to acknowledge the couple's kindness by sending him the photo of the youngster arriving in a safe haven.

Interestingly, some of those same photos found their way onto the desks of various American senators and congressmen. While Pearl Harbor's 'day of infamy' was still many months away and the United States still enjoyed neutrality, President Franklin Roosevelt was desperately seeking approval for a plan that

Bradley Streit's 1945 composite Christmas card depicting Simon Dew and Constable Harry Wharton in 1940 (inset), and again in 1945.

Courtesy, Mrs. Marlene Stewart Streit.

would permit American aid to be shipped to Great Britain.

There's little doubt that the photo of Toronto's young, defenceless, and extremely vulnerable 'war guest' stirred the hearts of many American law makers (many of whom were reluctant to become involved in what was deemed Europe's war).

Just weeks after the picture of the 'Cop and the Kid' began appearing in offices all over Washington, Bill 1776, Roosevelt's famous 'lend-lease' plan, was approved and $50 billion in aid was soon on its way to Mr. Churchill.

SMYTHE KNEW THE SCORE

January 17, 1993

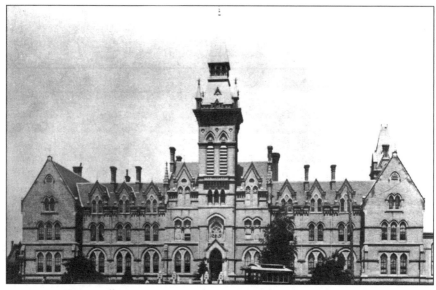

Knox College sat on the site of the proposed new home of the
Toronto Maple Leaf hockey team.

Ever since that long-ago Thursday evening, November 12, 1931, when 13,233 fans paid from 95¢ to $2.75 for a seat from which they could witness the first professional hockey game in the new sports arena on Carlton Street,

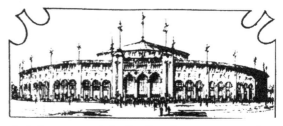

Artist's concept of the Spadina Avenue sports palace.

Maple Leaf Gardens has been home to our Toronto Maple Leafs.

The idea of building a new facility to replace the old, out-dated Arena Gardens, where the team had played since its inception, was a business decision, pure and simple. With a seating capacity of only 8,000 in the old Mutual Street building, it was getting more and more difficult for team owner Connie Smythe to come up with enough money to cover the ever-increasing salary demands of the better players in the NHL. More seats meant more income and a better chance at winning Lord Stanley's coveted trophy. Smythe was convinced that a new, larger facility was an absolute must if Toronto was ever to become a really successful hockey city.

Even though the financial markets had begun to show symptoms of an impending disaster Smythe, with help from some of Toronto's most influential

businessmen, was able to obtain sufficient financial backing to get the project started, on paper at least.

One of the first decisions that would have to be made was exactly where to locate the new arena. Smythe had his eye on a large parcel of land near the corner of Yonge and Fleet streets (the latter thoroughfare was renamed Lake Shore Boulevard in 1960). On part of the property he would erect his hockey palace while making provision across the street for a large parking lot with access to the arena via an underground tunnel, a perfect amenity for fans attending a game on a typical snowy, winter's night in Toronto.

Other features of the waterfront site were streetcar access from all parts of town, the absence of neighbourhood communities (who surely would fight the proposal), and restrictive zoning by-laws.

Unfortunately for Smythe, the land in question was unavailable for outright purchase, though the owners would have been pleased to lease him the parcel. For obvious reasons Smythe wanted no part of any leasing arrangement.

At precisely the same time that Smythe and the directors of the Maple Leafs were investigating the waterfront location, another group of businessmen (rumoured to have amongst their number 'capitalists' with financial interests in the Montreal Forum) was eyeing the old Knox Theological College site in the middle of Spadina Avenue, just north of College Street. It was this group's intention to tear down the old building, that had been built in 1874, and erect a 16,000-seat facility at a cost of $1.5 million with similar architectural features to the Olympic Arena in Detroit. The syndicate would then lease the new arena to Smythe or any other organization that wanted a place to feature sporting activities.

Needless to say, the Maple Leafs had no interest in the Spadina proposal.

Talks continued and before long, property on the north side of Wood Street, owned by the T. Eaton Company, came on the market. The arena was located just a couple of blocks east of the company's new College Street store, and officials believed the new arena would generate additional customers for its new venture.

However, Smythe preferred another chunk of Eaton property located a block to the south that fronted on Carlton Street and just steps from both Carlton and Yonge streetcar lines.

After considerable negotiating, Eaton's, through its vice-president J.J. Vaughan (who's Bayview Avenue estate has recently been renovated and made available for meetings and receptions), not only agreed to sell the property at the northwest corner of Church and Carlton, but agreed to purchase $25,000 worth of stock in the new sports arena as well.

The rest of the Maple Leaf Gardens story has to do with finding large sums of money in the midst of a worsening financial depression. With workers taking stock in lieu of real dollars and investment foresight on the part of several large banks and insurance companies, Smythe's dream was constructed in just six months.

Unfortunately, his Leafs dropped that first game to Chicago, two to one. But take heart dear fans. The team went on to win the 1931–32 Stanley Cup.

WHEN NIAGARA FROZE

January 31, 1993

Another form of bridge, this time the Falls View Bridge, succumbed to ice on
January 27, 1938. It was replaced by the present Rainbow Bridge.

Weather officials predicted that the weekend of Saturday and Sunday,
February 3 and 4, 1912, would be sunny and cold. And with the Toronto
papers reporting that a perfect ice bridge had formed across the Niagara River just
below the mighty cataract, the Falls would quickly become the destination for
thousands of sightseers. Among them would be Torontonians Eldridge Stanton
and his wife who lived at 19 Nanton Avenue in the city's fashionable Rosedale.

The young couple would board the Saturday morning train for the short trip
to Niagara Falls where they would reserve a room at one of that community's many
hotels and then venture down to the river's edge to witness up close one of nature's
most spectacular sights.

Massive ice bridges completely filling the Niagara gorge were a common
occurrence during the winter months those many years ago, the immensity of each
ice bridge being directly related to the severity and duration of sub-zero weather.
(Since 1964 a massive ice boom has been put in place prior to each winter season
to protect vulnerable hydro electric plants and other property located at the base

of the gorge. As a result, ice bridges emulating those of years gone by are but a memory.)

As more and more people discovered the Falls each winter, it was only a matter of time before the ice bridge itself would be littered with souvenir shops, photography booths, coffee and contraband whiskey stands, and the like giving the bridge the appearance of the main streets of the Canadian and American cities that straddled the river.

Upon their arrival at Niagara Falls, the Stantons checked into a small hotel where it was decided that they would spend the afternoon exploring many of the city's man-made and rather tacky attractions and leaving until the next day a trip out onto the ice bridge that had formed several weeks earlier.

Sunday dawned perfect. By noon, hundreds of tourists and local folks alike were busily exploring the hills and crevices of the bridge. Among them were the young couple from Toronto.

Suddenly, a loud crack was heard and the massive ice bridge began to quiver. Tiny fissures in the ice grew wider as people scrambled for the nearest shoreline. Shouts of "she's goin' out" and "run for your lives" filled the air. Within minutes, the once rock-solid ice bridge had been transformed into dozens of ice flows, each of which picked up speed as the river hurtled them downstream towards the dreaded whirlpool.

Caught on one of the larger chunks of ice were the Stantons and seven others, including local resident William 'Red' Hill, who was able to save, amongst others, Ignatius Roth. This latter gentleman was so thankful that he personally led the crusade to have Hill awarded the Carnegie Life Saving Medal for his 'superhuman' efforts that afternoon. Over the years, both 'Red' Hill and his sons became legendary as a result of their life-saving exploits and daredevil stunts on the Niagara River.

As the flow continued downstream, Roth's travelling companion, Burell Heacock, attempted to climb a rope lowered from the railway bridge only to lose his grasp and fall 50 or so feet into the raging water. His body was never found.

That left only the young Toronto couple on the flow, the husband anxiously searching for help, the wife kneeling as if in prayer. More ropes were thrown none of which could be grasped. Suddenly, the great chunk of ice dipped into the icy torrent. When it rose, only Eldridge was visible. His wife had vanished. Then as the flow entered the whirlpool, he too disappeared. Neither body was ever recovered.

Soon after the disaster, officials decreed that venturing out onto ice bridges in the Niagara River gorge would henceforth be prohibited.

PRINCESS OF A THEATRE

February 7, 1993

Princess Theatre shortly after renovations in 1900.

It won't be long before Toronto will be home to another fine playhouse. Under construction on a site just west of the historic Royal Alexandra and across the street from the new Metro Hall, the new 2,000-seat theatre is scheduled to open, officially, on May 26 with the Canadian premiere of *Miss Saigon*.

At a recent press conference Ed and David Mirvish announced that the name of the new facility would be the Princess of Wales, in honour of Her Royal Highness Diana, Princess of Wales, who paid a special visit to the Royal Alexandra Theatre in 1991.

Interestingly, the name of the new theatre fits perfectly within the long list of other 'royal' cinemas and playhouses that have been part of Toronto's long-time theatre history. At various times throughout the early years of this century, theatre goers could attend the Majestic and Regent on Adelaide West, the Victoria on Richmond East, the Imperial, His Majesty's, Empress, York and Queen's Royal on Yonge, the Empire, Rex, and Prince Edward on Queen, the Duchess and Royal on Dundas, another Royal, the King, and Windsor on College, the King George on Bloor, Royal George on St. Clair, and (in honour of the male possessor of the title) the Prince of Wales on Danforth near Woodbine.

As mentioned, the new Princess of Wales will be located a block or so west of the Royal Alexandra Theatre, itself a landmark structure that, according to the builder Cawthra Mulock's son, was 'presented' to Torontonians in 1907 to ensure

that the city would be acknowledged by theatre goers worldwide. It was named for Queen Alexandra, wife of the reigning monarch King Edward VII, who himself was honoured with the opening of the city's newest and most gracious hotel four years earlier.

A little to the east of the Royal Alexandra and on the opposite side of King Street (where University Avenue now cuts through) was another theatre that, too, was part of the 'royal' connection. Erected in 1889–90, the structure was originally known as the Academy of Music and during the first few years of its existence served as a music hall where the premiere American performances of both *Lohengrin* and *Die Walkure* were presented. In addition to musical performances, the Academy of Music was also the site of one of the largest political gatherings in the city's history when Prime Minister Macdonald appeared on its stage in 1891. It was during his appearance at the Princess that Sir John proclaimed to all that "a British subject I was born, a British subject I will die." A few months later, he did just that.

Following the opening of Hart Massey's new music hall a few blocks to the east in 1894, the owner of the Academy decided to convert his property into a lyric theatre. The first presentation at the remodelled and renamed theatre took place on the evening of Monday, September 2, 1895, when the new Princess Theatre presented Frederick Warde, described by his press agent as "America's greatest player," in the romantic drama *Runnymede* ... "Ticket prices 25 cents to $1.50, tickets now on sale, telephone 2191." A few years later a Toronto youngster by the name of Gladys Smith appeared on the theatre's stage in a bit part in *The Silver King*. We know little Gladys better today as 'America's Sweetheart' Mary Pickford.

In 1900, more alterations were made to the structure and it then became home to high-class entertainment under the direction of the well-known and influential American producers Messrs. Klaw and Erlanger.

A few years later operettas found a home at the Princess and in 1907 (the same year that the Royal Alexandra across the street opened) the first Canadian presentation of *Madame Butterfly* thrilled the audience at the Princess.

Then, early in the morning of May 7, 1915, the week-long run of Henry Miller in *Daddy Long-Legs* was interrupted when the Princess was almost totally destroyed by fire.

The theatre was quickly rebuilt and enthusiastic audiences soon began filling its 1,800 seats. But the future of the old Princess was less than bright. There were rumblings over at City Hall that as part of a Depression work programme, University Avenue was going to be extended south of King. The Princess was obviously in the way.

As it turned out, one of the last performers to appear on the stage of the old Princess was the legendary song writer/performer George M. Cohan who was in town November 20, 21, and 22, 1930, in a play entitled *The Tavern*. Not long after, the theatre was dark.

While wrecking crews began demolishing the old theatre on June 1, 1931, more than a year went by before arbitration resulted in the city paying $371,088 for the old theatre site.

CROSS HONOURS HEROIC DEEDS

March 14, 1993

Once again, an attempt has been made to abolish another of this country's cherished customs. This time, however, the attempt was thwarted.

For years, a few misguided politicians up in the nation's capital attempted to have the highly venerated Victoria Cross replaced by some other form of decoration. But thanks to the efforts of soldiers and veterans alike, the VC will remain as this country's highest military honour.

While the overall appearance of the medal will remain unchanged, there will be a slight modification in the wording appearing on the decoration awarded to Canadians. The Latin expression PRO VALORE will be used in place of FOR VALOUR which has appeared on the medal ever since its inception more than a century-and-a-half ago.

The origin of the Victoria Cross can be

A portrait of Private Timothy O'Hea and his Victoria Cross are displayed together in a place of honour in the British Rifle Brigade Museum in Winchester, England.

traced to a desire by Queen Victoria to reward officers and enlisted men alike for gallant bravery against the Russians during the Crimean campaign that spanned the years 1854–56.

The design of the decoration emulates a Maltese cross with all medals awarded up until 1942 cast from the molten metal of a Russian cannon captured during the battle for Sebastopol. Since then the medal has been cast in bronze of similar composition but without the historical significance. Measuring 1½ inches across,

one side of the VC features the Royal Crown surmounted by a lion with a scroll below the crown bearing the inscription FOR VALOUR. The reverse has raised edges with the date of the act for which the medal was awarded engraved within a raised central circle. The medal is attached to a straight bar ornamented with laurels and is worn suspended from a crimson ribbon.

During the period of time the Victoria Cross has been in existence, almost 1,350 have been awarded, the last pair to a colonel and sergeant in the 1982 Falklands War.

Of this total, 94 have gone to Canadians or to individuals serving with Canadian forces. The breakdown by conflict is: Crimean War 1854–56 – 1, Indian Mutiny 1857–58 – 2, Little Andaman Island 1867 – 1, South African War 1899–1902 – 4, First World War 1914–18 – 70, and Second World War 1939–45 – 16.

Interestingly, the first VC awarded to a Canadian was given to a 21-year-old soldier who was born in 1833 in Toronto (then still called York) and who had risen to the rank of lieutenant in the 11th Hussars (Prince Albert's Own Regiment of Foot). The incident for which Alexander Robert Dunn received his medal occurred on October 25, 1854, during the celebrated Charge of the Light Brigade at Balaclava in the Crimea. The medal is in the possession of Upper Canada College, Dunn's school. A provincial plaque honouring the young man stands on the east side of Spadina Avenue, just south of King.

Other VC winners with close Toronto connections (and the date of the incident) include Denis Dempsey (1857), Churchill Cockburn (1900), Fred Fisher (1915), George Richardson (1916), Colin Barron (1917), George Kerr (1918), William Merrifield (1918), Walter Rayfield (1918), David Hornell (1944), Fred Tilston (1945), and Fred Topham (1945).

Soon after the Victoria Cross was established it was possible for the decoration to be awarded for bravery not necessarily demonstrated on the field of battle. That makes the Timothy O'Hea's VC of special significance.

O'Hea, a native of Bantry, County Cork, Ireland, had been stationed in Canada with other members of the British Rifle Brigade (Prince Consort's Own) to assist Canadian forces defend against aggression by Fenian rebels into Canada from camps in the northern States.

Skirmishes had broken out on the Niagara frontier and it became necessary to send a large quantity of gunpowder from Quebec City to troops at Niagara-on-the-Lake. O'Hea and several other members of his regiment were assigned to escort the ammunition that had been loaded into a boxcar and attached to an immigrant train transporting more than 300 unsuspecting settlers to the Canadian west.

As the train approached the Danville railway station, O'Hea noticed the boxcar containing the gunpowder was on fire. As the train crew and the rest of the sentries ran for cover, O'Hea did just the opposite. Finding a supply of water nearby, the young private spent the next hour dousing the flames. His actions prevented a major disaster and as a result Private O'Hea was awarded the Victoria Cross, the only VC to ever be awarded in Canada.

ARROW'S DEMISE

March 28, 1993

The *Toronto Telegram* ran this artist's concept of the still secret Arrow flying over
Toronto in the September 26, 1957, edition of the newspaper.

As much as I try to feature an entirely new subject for every Sunday's "The Way
We Were" column, certain events from our city's past are so momentous they
deserve repeated inclusion in this feature. One such event was the creation of the
awesome Avro CF-105 Arrow supersonic jet interceptor. Last Thursday, March 25,
marked the 36th anniversary of the maiden flight of this remarkable Canadian-
designed and -built aircraft, a plane that some say has yet to be bettered.

In an ironic twist of fate, just six days after that history-making flight, John
Diefenbaker and his federal Progressive Conservative party attained the greatest
political majority in Canadian history. Less than two years later those same PCs
'shot' the Arrow out of the sky.

A.V. Roe Canada Ltd. was established in 1945 by England's Hawker
Siddeley Group to provide Canada with a domestic aircraft design and produc-
tion facility. The new company took over the former Victory Aircraft plant
located on the northern fringe of Malton Airport (which was renamed Pearson

International Airport in 1983) where the mighty Lancaster bomber had been built during the war.

Soon after the end of hostilities, the Royal Canadian Air Force began searching for a new jet fighter with which to re-equip its front-line fighter squadrons.

Nothing then being produced by American or British aircraft companies filled the bill. The RCAF then turned to Avro and requested proposals for a two-seat, twin-engine, long-range, all-weather jet fighter. On January 19, 1950, the first Canadian-designed and -built jet, the CF-100, flew for the first time. Over the next nine years, 692 CF-100s were built at the Malton factory.

A few years after the CF-100 first flew, the air force once again began looking for a replacement aircraft. This time they were after a "supersonic all-weather interceptor." One plane they looked at was the American F-101 *Voodoo* which they rejected as being incapable of fulfilling all operational requirements. (Here's another irony in the Arrow story, when the Canadian government canceled the Arrow in late February 1959, the aging *Voodoo* was selected to replace it.)

The Avro people responded to the RCAF's request by producing, on paper, the C-105. The design was presented to air force officials in May of 1953 and they liked what they saw. The C-105 was redesignated CF-105 and the Arrow was born.

The creative genius of the Avro staff then began to work in earnest and thousands of man-hours later, on October 4, 1957, to be exact, Arrow *RL25201*, made its debut as the Minister of Defence, George R. Pearkes V.C., trumpeted: "I have the pleasure of unveiling the Avro Arrow – Canada's first supersonic aircraft – a symbol of a new era for Canada in the air."

More hours of testing followed. Then it was time to see if the thing would fly. Saturday, March 22, 1958, was selected as the day of the new plane's inaugural flight. However, a minor hydraulic fluid leak was detected and the date of the flight was put off until the following Tuesday.

At exactly 9:51 am, March 25, 1958, Canada's Arrow was airborne. Less than two years later it was dead.

The entire story of the Arrow project is now available on video from Aviation Videos Ltd. *Arrow, from Dream to Destruction* is a one-hour-long documentary, in colour, tracing the complete Arrow programme and includes footage of the design facilities, historic test flights, plus actual trial flights by all five Arrows that did get airborne before the Diefenbaker government nullified Canada's brave attempt to become a world leader in the field of aviation.

TORONTO'S MANY BASEBALL 'PITCHES'

April 11, 1993

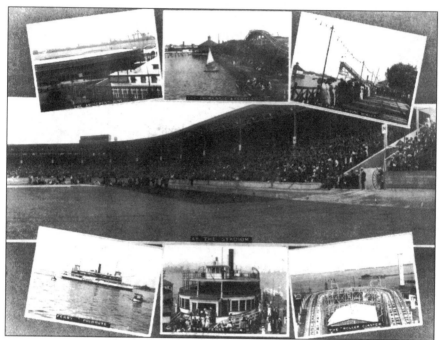

The Toronto ball park was part of the Hanlan's Point amusement park and was accessible only by ferryboats like *Trillium*.

Who'll ever forget that snowy early April afternoon, 16 years ago, when our Jays won their very first ball game defeating Chicago White Sox, nine to five, at Exhibition Stadium? Fifteen seasons later, the team won the World Series pennant defeating the Braves from Atlanta, four to three, in game six.

As relative newcomers in the majors, the shock of a Canadian team winning what had always been an American icon didn't sit well with a lot of fans. Nevertheless, the boys are back in town and on their way to winning that pennant once again.

The fact that a major league franchise took so long coming to Toronto certainly wasn't for the lack of trying by local entrepreneurs. Jack Kent Cooke, for instance, owner of the International league's Toronto Maple Leaf team since 1951, first began agitating for a franchise in 1954 when he put in a bid for the financially troubled Detroit Tigers.

The move was unsuccessful, so Cooke followed with an offer for the Chicago team (the same Sox the Jays defeated in that historic game April 7, 1977, ... talk about coincidence).

Once again his 'pitch' was rejected. Feeling his repeated failures were because Toronto lacked a major-league-size stadium, Cooke was quoted as being willing to work with Etobicoke politicians to erect a large new facility near the Woodbine race track. Apparently his offer fell on deaf ears. He then volunteered to spend $6 million of his own money to build a stadium in Riverdale Park, adjacent to the proposed Don Valley Parkway. This time, the city fathers refused his request for the land as it sat on a flood plain. (Wonder why someone didn't tell the Ataratiri people that?)

Cooke made one final attempt in 1959 when he sought a franchise in a new league that was established when New York lost its Dodgers and Giants to California. With a dejected New York no longer in the majors, it was felt that a new team from the 'Big Apple' could anchor the Continental League that would be made up of teams from New York, Buffalo, Houston, Denver, Atlanta, Minneapolis-St. Paul, Dallas, and (at last) Toronto.

Recognizing the threat this new league would have on the existing American and National leagues, officials moved quickly to authorize expansion. As potential members of the Continental League were absorbed into the existing leagues, plans for the new league fizzled. Once the dust had settled, Toronto was again out in the cold.

While Cooke's attempts were the most persistent, other people had tried. In fact, decades earlier Canadian-born Arthur Irwin (inventor of the padded baseball glove, major league player, and manager) had become part-owner and business manager of the Toronto team. In 1916, Irwin led a group that made a concerted attempt to relocate the Washington, D.C., American League franchise from the USA capital to the very British city of Toronto.

Newspapers all over the States reacted swiftly when this possibility came to light.

The New York *Tribune* recorded that:

> The rumour that Washington will lose its American league franchise persists. It seems that the present administration does not patronize baseball very extensively and that Walter Johnson has been pitching to empty seats. The Democrats who came to Washington with William Jennings Bryant do not patronize the national game. The franchise that Washington will probably lose will go to Toronto, Canada. The Canadian city has developed a tremendous interest in baseball and the American League magnates, who are business men first, will develop to a greater extent if the Canadians see a chance of getting some big league baseball. Walter Johnson is likely to be battling under the flag of the Dominion next year.

As concerned as many Americans were, the unthinkable didn't happen. In fact, it wasn't until 1960 that the Senators were finally dispatched to Minnesota.

However, no matter how hard Toronto tried to get that illusive franchise, nothing happened until 1976 when people like Howard Webster, Donald McDougall, and, of course, Paul Godfrey completed a deal that finally saw the birth of our Blue Jays.

SUMMER TIME BLUES

April 18, 1993

B y now I guess everyone is aware that for the past two weeks we've been on Daylight Saving Time. If you forgot, I'll wait a few moments while you set your clocks ...

Now, where was I? Oh yes, the idea of advancing timepieces one full hour in the spring was originally put into effect by several European countries in the early stages of the first Great War. Great Britain, in an effort to alleviate a critical fuel shortage brought on by the seemingly endless war, finally got around to introducing the measure in 1916.

While additional hours of daylight appeared to be a good thing all round for the country, it wasn't long before England's farmers were up in arms complaining that they were forced to milk cows in the dark and then wait idly until the sun had evaporated the dew so the harvesting of hay could commence.

Nevertheless, the advantages of extra daylight superseded the complaints and the government's 'summer time' act remained in force.

Two more years of carnage on the battlefields of Europe passed and on March 31, 1918, the American government passed their own version of the 'summer time' act. It soon became obvious that Canada, too, would have to advance the clocks now that her neighbours to the south were to be an hour ahead. A bill, designated as the Daylight Saving Act, 1918, was introduced in Parliament, and although as a war measure act it passed without an adverse vote, that didn't stop seventeen politicians from voicing opposition during the second reading. As in the United States and Great Britain, Canadian farmers, too, were to suffer as a result of the time shift.

In spite of the opposition the law passed easily and on Sunday, April 14, 1918, 75 years ago last Wednesday, most Canadians experienced daylight saving time for the very first time. I say most since several smaller communities had already established 'summer time' on their own. But, here in Toronto that mid-April Sunday was certainly different.

The following day's paper reported the event thus:

> The deed's been done. Toronto, with the rest of Canada, is now saving daylight. Quite probably a good many folk found it unpleasant turning out of bed betimes [early] but they will feel better after enjoying the prolonged evening. The Sunday start gave folks an opportunity to somewhat accustom themselves to the change, but it takes a day's work to make the earlier bedtime entirely satisfactory.

Several unusual and embarrassing incidents occurred that Sunday. A Protestant clergyman didn't arrive at his church until 11:30 am, while a Roman Catholic priest failed to turn up at early mass forcing his parishioners to wait an hour for his appearance.

Even the local police were caught in the time warp. A plan to raid a local gambling house was set for 8:00 am Sunday when it was assumed the cards would be flying. Figuring that the participants wouldn't have remembered to set their timepieces ahead, the lawmen made their move at the unadjusted 8:00 am.

Unfortunately, the bad guys had remembered. The raid was literally a bust.

With 'old' City Hall's clock undergoing major repairs in the spring of 1923, the city officials didn't have to worry about adjusting its hands.

AN EVENING OUT AT THE THEATRE

May 23, 1993

Prince of Wales Theatre on the Danforth, 1927.

With the official opening of Ed and David Mirvish's new Princess of Wales Theatre just days away, it's interesting to look back a few decades to a time when many Torontonians spent the evening out at a theatre called the Prince of Wales.

William A. 'Billy' Summerville (1879–1958).

While the new King Street facility was named in honour of Diana, the present Princess of Wales, the other theatre, which opened in 1924 on the north side of Danforth Avenue just east of Woodbine, honoured Edward Albert Christian George Andrew Patrick David, eldest son of King George V and Queen Mary, who had been created Prince of Wales at the Investiture at Caernarvon Castle on July 13, 1911.

Now, depending on whether you accept the facts as recorded in the English history books or the chronicles of the Welsh people, Edward was either the 20th or 23rd individual to hold the title of Prince of Wales. Missing from the British records are David and Llywellyn II (reputed to be the first two to hold the title) and a chap named Owen Glyn Dwr who held the title in the 15th century.

The Prince of Wales, after whom Toronto's theatre out the Danforth was named (please don't ask why it's referred to as 'the Danforth' cause I have no idea),

was known to his intimate friends simply as David. He became King Edward upon the death of his father in January of 1936, though the young man was never crowned, preferring to abdicate instead so he could marry his beloved Mrs. Simpson. He died in 1972.

The man responsible for Toronto's Prince of Wales Theatre was an interesting individual in his own right. William 'Billy' Summerville was born in the small hamlet of Cargill, Ontario, in 1879 and moved to Toronto with his parents when he was just three years of age.

A short 10 years later Billy signed up as a cornetist with the city's famed 48th Highlanders and in 1893 toured both Canada and the States with that illustrious regiment. Perhaps it was while on tour in exciting New York City that the young man was bitten by the show business bug because before long Billy was a member of one of that city's numerous musical comedy groups. He later signed up with the Great West Minstrels, one of America's most popular entertainment companies of the day.

Wishing to re-establish his roots in Toronto, Summerville returned and obtained employment with the Grand Opera House Theatre orchestra. He loved to tell people that he was in the pit the night owner Ambrose Small vanished from the face of the earth, a mystery story that nearly 75 years later remains unsolved.

Summerville also performed with the famous Jack Arthur Orchestra that provided musical accompaniment at the Uptown and recently restored Pantages theatres.

Not long after returning to Toronto, Summerville was bitten by another bug, this time of the political strain. He decided to contest the Ward 1 aldermanic seat in the city's 1921 municipal election. Having established himself as a well-known and respected businessman and entrepreneur, he won. He represented the ward for seven years followed by two more terms on the Board of Control. In 1937 he entered provincial politics and sat at Queen's Park until 1943 as the member for Riverdale.

It was while serving as alderman for Ward 1 that Summerville decided to go back into show business, though this time in a slightly different way. He would build a movie house. And so it was that in 1924 the new Prince of Wales came into being.

For the next half-century Billy Summerville's theatre on the Danforth, one of several he was to build and operate in the city's east end, was one of the neighbourhood's most popular attractions, providing, in its earliest days, not only screen presentations, both silent movies and the new-fangled 'talkies,' but entertaining vaudeville acts as well.

In tribute to Summerville's leading role in the movie industry, on November 29, 1957, he was awarded the Pioneer of the Year Award by the Canadian Picture Pioneers.

Exactly one year later, Billy Summerville died.

The Prince of Wales continued to operate for another few years before it, too, came to an ignominious end in 1966. Today, a grocery store occupies the site.

Billy left us another legacy – his son, Donald Summerville, who served an all-too-brief term as mayor of Toronto in 1963.

By the way, my thanks to Billy's grandson, Dean, for helping with some of the facts in this article.

TORONTO ON THE SEAS

July 25, 1993

I name this ship Toronto. *May God bless her,*
and guard and guide all who sail in her.

The date was November 25, 1943, and with these few solemn words, Mrs. Fred Conboy, wife of Toronto's mayor, christened the latest addition to the Royal Canadian Navy's fast-growing wartime fleet.

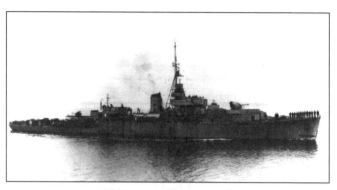

HMCS *Toronto,* May 31, 1945.
Courtesy of Department of National Defence.

Built and launched two months earlier at the rambling Davie shipbuilding yard in Lauzon, Quebec, *Toronto* was one of 33 such vessels that were constructed as part of the '1942-43 frigate programme,' a frigate being a larger and more powerful ocean-going version of the RCN's ubiquitous little corvette, a special kind of warship that itself is the subject of a new book, *Corvettes of the Royal Canadian Navy –* *1939–1945* (Vanwell Publishing) by marine historian Ken Macpherson.

These new frigates were just over 300 feet in length (as compared with the corvette's 205-foot length) and were propelled by a pair of reciprocating corvette engines that gave the craft a top speed of 19 knots. Frigates also boasted twice the

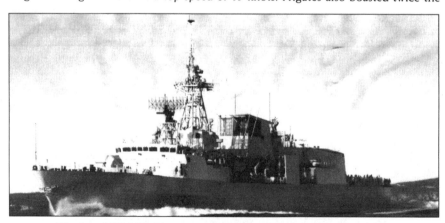

The 'new' HMCS *Toronto* undergoing sea trials, September 1992.
Courtesy of Department of National Defence.

endurance of the smaller corvettes plus more spacious crew accommodation and, on later versions, increased fire power and better detection equipment. In the latter category was a new invention called 'asdic,' an anti-submarine detection system that was developed by Canadian and British scientists in total secrecy within the confines of the underground tunnel connecting Casa Loma and the castle's nearby stables.

Following *Toronto's* christening that chilly November afternoon nearly a half-century ago, the vessel underwent more than five months of 'fitting out,' following which she was almost ready for active duty. First, though, a commissioning ceremony was held on May 6, 1944, followed a few weeks later by departure for Bermuda where mandatory 'working-up' exercises were conducted.

Finally, on July 24, 1944, HMCS *Toronto* returned to Halifax "to join the fray." She commenced operational duties with Escort Group-16 (and later with EG-13), escorting Allied shipping through the submarine-infested waters of the Gulf of St. Lawrence.

For the duration of the war *Toronto*, with six sister ships, performed the thankless task of unending hours of tedious patrol and escort duty, periodically enlivened by sightings of periscopes and torpedo wakes.

Following the war, *Toronto* was used as a training ship until retired in November 1945. Soon after the outbreak of the Korean War, the vessel was reactivated, underwent conversion to a Prestonian-Class frigate, and was recommissioned November 26, 1953. Two years later, following service with the NATO fleet, HMCS *Toronto* was loaned to the Royal Norwegian Navy and renamed *Garm*. In 1959, the craft was permanently transferred to the RNN, reclassified as a 'torpedo boat escort ship,' and renamed once again, this time to *Valkyrien*. In 1977, the former RCN frigate HMCS *Toronto* was scrapped.

Tomorrow, a new HMCS *Toronto* will arrive in the Port of Toronto for an eight-day visit. This *Toronto* is the third of a fleet of 12 patrol frigates being built by the federal government at shipyards in Quebec and New Brunswick. Interestingly, diverse components of this $516-million vessel emanate from plants within the Greater Metro area. Additionally, many of her crew of 225 are from Metro Toronto and environs.

Some of the events to which the public is invited include:

- Monday, July 26 at 9:35 am – HMCS *Haida* gun salute, Ontario Place.
- 2:00 pm – HMCS *Toronto's* arrival at Maple Leaf Quay,
- Harbourfront, navy band to play.
- Sun readers are invited to 'come aboard' the steam ferry *Trillium* as we sail out to welcome HMCS *Toronto*. See details on coupon below.
- Tuesday, July 27 at 10:00 am – parade up Bay Street followed by wreath-laying ceremony in front of 'old' City Hall.
- Friday, July 30 through Monday, August 2 – ship open to the public from 1:30 pm to 4:30 pm, daily.

The new HMCS Toronto *was commissioned on July 29, 1993.*

FOUNDING OF TORONTO

August 1, 1993

The arrival in Toronto Harbour early last week of our navy's new patrol frigate HMCS *Toronto* coincided, *almost to the day*, with the 200th anniversary of John Graves Simcoe's arrival in that same harbour aboard his small vessel HMS *Mississauga*.

It was on July 29, 1793, that the city's founder (and first lieutenant-governor of our province) sailed into the harbour via the old west gap (the east entrance had yet to be formed) and, after spending the night on board ship, came ashore to take the first steps in establishing a community that has evolved into the present-day Metropolitan Toronto.

To be sure, there had been settlements in the Toronto area prior to 1793 including those established by the native people and, from 1850 until 1859, a small French trading post known as Fort Rouillé (that stood near the site of the present CNE Bandshell). However, it wasn't until Simcoe stepped ashore (accompanied by his family, a few government officials, and members of the Queen's Rangers) exactly two centuries ago last Friday that a permanent community began to take shape.

The reason for the lieutenant-governor's decision to establish a settlement on the site of today's Toronto was really due to fears that his new responsibility, the Province of Upper Canada (Ontario), would sooner or later be attacked by military forces from south of the border. American leaders were at serious odds with the British government over several matters, not the least of which was the perceived British complicity with the aboriginal peoples who had soundly defeated the American army on several recent occasions.

Now, with Great Britain drawn into a war with the French republic, many American leaders were proclaiming that the time was right to dislodge the King's troops from the entire North American continent starting with a raid on the recently established Province of Upper Canada.

Simcoe, with a view to finding a place where he could build fighting ships necessary to defend his province, toured the north shore of Lake Ontario and in May of 1793 was delighted to find a clearing in the forest in front of which was a substantial harbour protected by a peninsula connected to the lake by an easily defensible entrance at the west end. (A second gap at the east end of the bay that would give us the now familiar Toronto Island formation was still a half-century in the future.)

Simcoe had a site not only for his military shipyard but a community as well, for in his wife Elizabeth's fascinating diary, under the date May 11, 1793, she reports that "Colonel Simcoe speaks in praise of the harbour and a fine spot near it covered with large oaks which he intends to fix upon as a site for a town." A little more than two months after his first visit to Toronto (as the native people referred to the area), 100 Queen's Rangers under the command of Captain Aeneas Shaw

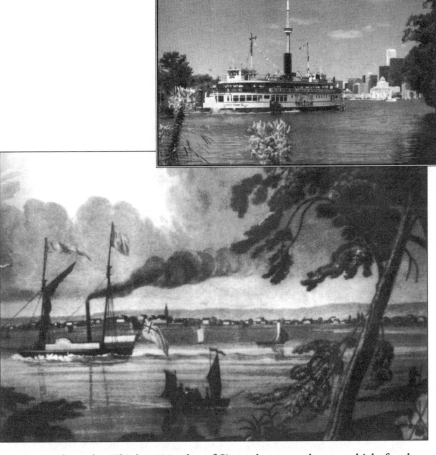

Surveyor Alexander Aikin's 1793 plan of Simcoe's new settlement which, for the first 41 years of its existence, was called York, reverting to the present (and original) name of Toronto when the town became the province's first city in 1834.

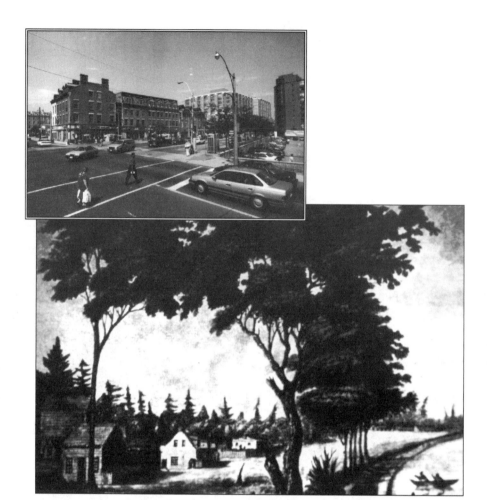

This plan shows the original townsite (10 blocks bounded by today's George, Adelaide, Berkeley and Front streets). Also visible are the site of military garrison Fort York, opposite the west end of the peninsula, the surveyor's 'base line' (today's Queen Street), numbered 100-acre parcels of land (that stretched north to the present Bloor Street), and the Don River, so named by Mrs. Simcoe.

(for whom Shaw Street was named) arrived at the clearing from Newark (now Niagara-on-the-Lake) to begin construction of the first military fortifications on the site of today's restored Fort York.

The first 'residence' came a little later when the Simcoe family moved into a tent that had been purchased from the estate of the celebrated explorer James Cook.

In celebration of Toronto's 200th anniversary, several events will be held next weekend to which the public is invited:

- August 7, 11:00 am – Simcoe Landing re-enactment at Maple Leaf Quay, Harbourfront.
- 3:00 pm – battle re-enactment, Fort York.
- August 8, 11:00 am – Christening of York re-enactment, Fort York.
- 1:00 pm – battle re-enactment, Hanlan's Point.

Call the Toronto 200 Hotline at 392-1993 for more details.

SERVING COUNTRY WITH DISTINCTION

August 29, 1993

HMCS *Haida,* rescued from the wreckers, found a safe haven at Ontario Place.
Courtesy Ontario Place.

Tomorrow, August 30, 1993, one of the most famous of all Canadian fighting ships will celebrate its 50th anniversary. It was on August 30, 1943, that HMCS *Haida* was commissioned at the massive shipyard of Vickers-Armstrong Limited at Newcastle-Upon-Tyne, England.

Her launching had actually taken place almost exactly one year earlier, but it took all of the intervening 12 months to get *Haida* ready for action.

Haida was the fourth of eight Tribal Class destroyers to enter service with the Royal Canadian Navy. She followed *Iroquois*, the ill-fated *Athabaskan* (sunk with the loss of 128 officers and men), and *Huron* into service. In total 27 'Tribals' were built (16 for the Royal Navy, three for the Royal Australian Navy, plus the RCN's eight), and of this number 13 were lost during the war.

Haida's first taste of action was on the Murmansk Run escorting convoys laden with much-needed supplies into ports in northern Russia. She was present on December 26, 1943, when ships of the British Home Fleet led by *Duke of York* were successful in sinking the huge German battle cruiser *Scharnhorst.*

Early the following year, as the tide of battle began to change in favour of the Allies, *Haida* was assigned to the 10th Destroyer Flotilla operating out of Plymouth. Assisted by other ships of the RCN, RN, and Polish Navy *Haida* began clearing enemy ships from the English Channel in anticipation of the 'D-Day' landings.

It was during this period of action that *Haida* attained the distinction of destroying more enemy vessels than any other ship in the RCN.

Sadly, it was also during this action that her sister ship, *Athabaskan*, suffered a torpedo hit followed by an immense explosion that quickly sent her to the bottom. *Haida* managed to avenge the sinking by destroying one of *Athabaskan*'s attackers. She also rescued 42 of the survivors. In a separate rescue action, three members of *Haida*'s motor cutter crew managed to save six more of the *Athabaskan*'s crew.

Following the successful Normandy landings, *Haida* continued her patrols in the channel until ordered back to Halifax for refit. Three months later, the feisty craft was back in business destined to finish out the remaining few months of the war serving in the Arctic and off the coast of Norway.

With the fall of Germany on May 8, 1945, plans to convert *Haida* for action in the Pacific theatre commenced, but V-J Day brought all work to a halt.

The next few years saw the ship assigned to the Atlantic fleet where she served until she underwent another major refitting that saw *Haida* emerge in early 1952 as a 'destroyer-escort' with new anti-submarine capabilities.

Soon thereafter *Haida* sailed for Korea where a 'police action' had been under way since the summer of 1951. She did two tours of duty where once again the Canadian fighting vessel did herself proud.

After Korea, *Haida* served with the NATO Atlantic fleet until taken out of service in 1963 and decommissioned on October 11 of that year.

It was about this time that a group of concerned Torontonians, fearful that the country's most famous warship, with many close ties with the provincial capital including a goodwill visit to the city in the summer of 1963, would simply be another victim of the wreckers' acetylene torches.

Haida was purchased from the government by the Preserve *Haida* Organization (later known as *Haida* Inc.), and eventually towed through the seaway and moored at the foot of York Street on August 25, 1964, where she awaited an admiring public.

Actually, it was anticipated that *Haida* would ultimately find a place of prominence in a proposed memorial park to be located east of the CNE grounds. While this project never materialized, sympathetic ex-navy personnel in power at Queen's Park helped find her a home at the province's newest attraction, and in May of 1971 *Haida* was ready once again to greet admiring crowds when Ontario Place opened.

• • •

The public is invited to attend special 50th Anniversary celebrations on board *Haida* tomorrow. Events begin at 10:30 am with a special gun salute. Official greetings and the cake-cutting programme start at 12:00 noon. Free with admission to CNE/Ontario Place.